WALES
THE GOLDEN AGE
OF PICTURE POSTCARDS

David Gwynn

AMBERLEY

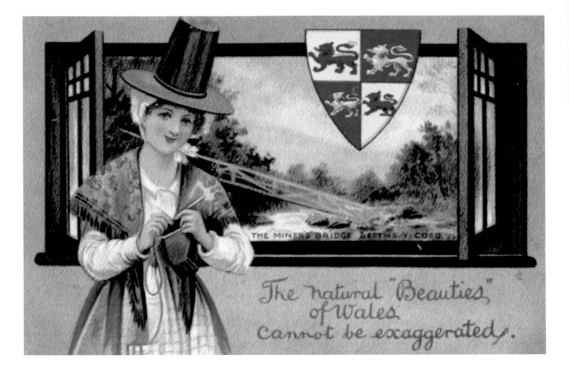

THE MINERS BRIDGE BETTWS Y COED.

The natural "Beauties" of Wales Cannot be exaggerated.

I feel that this one postcard encapsulates the spirit of this book. It brings together the people, the pageantry, a little bit of humour, and the wonderful scenery of Wales.

First published 2009

Amberley Publishing
Cirencester Road, Chalford,
Stroud, Gloucestershire, GL6 8PE

www.amberley-books.com

British Library Cataloguing in Publication Data.
A catalogue record for this book is available from the British Library.

ISBN 978 1 84868 303 7

Typesetting and Origination by Amberley Publishing.
Printed in Great Britain.

Contents

Acknowledgements

I would like to thank my wife Alicia for her invaluable help in the production of this book. She has gamely read and re-read the many drafts searching for errors and offering advice.

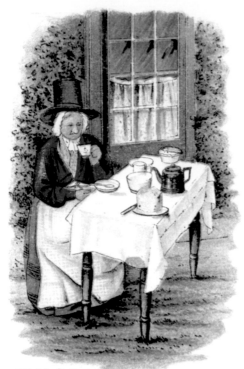

Welsh Costume.

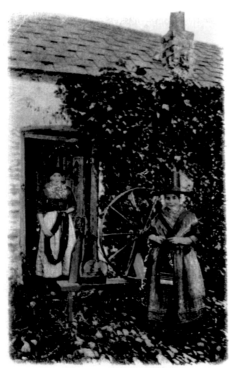

WELSH COSTUMES.

Introduction

Picture postcards first appeared in the 1870s in Europe in the form of advertising cards. The postal regulations did not allow for the message and the address to appear on the same side of the card, and although the picture element of these cards came to dominate the message side of the postcard, the other side of the card had to be exclusively for the address. In Great Britain, after 1894, private publishers began to produce postcards. At first 'Court size' postcards, which were slightly smaller than later postcards, appeared with attractive illustrations on the message side. My first illustration shows a rare Welsh Court size postcard featuring a Welsh lady having afternoon tea on her lawn. Within a few years, the postcards became larger, but still had to have the address on one side and the message on the other. One such 'undivided back' postcard is shown in the second illustration, where two Welsh ladies are standing outside their whitewashed cottage. In 1902, however, Britain became the first country to allow the message side of a postcard to be divided, so that the message and the address could be written on the same side. The other side could be devoted entirely to a picture. This move heralded an explosion in the production of picture postcards, and the appearance of a new hobby – postcard collecting. The years from 1902 to 1914 became known as the Golden Age of the Picture Postcard. During these years a number of major publishers mass produced millions of postcards covering every possible topic, whilst small, local photographers produced limited editions of postcards of local events.

Wales and the Picture Postcard

The enthusiasm for the picture postcard that blossomed from the late nineteenth century up to the First World War was felt in Wales just as much as in the rest of Britain. Large-scale publishers of postcards included Welsh scenes in their repertoire, and small local publishers and photographers were also busy producing local interest cards in small quantities. With a lively tourist trade, millions of postcards were bought and posted in Wales during that period. However, not just pretty tourist scenes adorned the racks of stationers and village stores. A considerable number of the postcards published for sale in Wales were humorous cards that poked gentle fun at the Welsh, their language, their customs, and even the weather. On the other hand, patriotic cards lauded the achievements of Welsh heroes of old, as well as current Welsh heroes such as David Lloyd George, Prime Minister from 1916 to 1922. There were also postcards that celebrated Welsh culture, heritage and traditions, as well as the everyday lives of the people both in the towns and rural areas. In this book my aim will be to examine the range of postcards that were sold in Wales in the early years of the twentieth century, and to explain how Wales was portrayed through them.

Pageantry and Patriotism

For many people living in England, Wales could have been a foreign country. It had a different language, unpronounceable place-names and a distinct national dress. Much of its history was different to that of England and visiting Wales must have seemed like an adventure for many who came on holiday. History has left its mark on Wales. The great castles built by the Normans and the English kings such as Edward I dominate the landscape. The scars of the Industrial Revolution can still be seen in the valleys of South Wales. A great maritime heritage has meant a run of ports along the South Wales coast. Most of all though, the nation's history has influenced the people of Wales. In the nineteenth century, Welsh pupils learnt only English history – especially that of the growth of the British Empire. However, by the end of that century there had come about a growth of interest in Welsh history, especially amongst the aspiring middle classes. A renewed fascination with a mythical Celtic past developed along with a growing feeling of Welshness, that Wales was a distinct nation with a unique history.

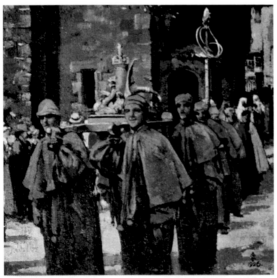

GORSEDD Y BEIRDD **CARIO'R CORN HIRLAS**

THE Gorsedd of the Bards, claimed by some to be derived from druidic rites and ceremonies prevalent in Britain in pre-Christian times, is a picturesque pageant held annually in connection with the Royal National Eisteddfod of Wales.

Druids, ovates, bards, chief musicians, and musicians are initiated ; orations are given, the harp is played and penillion sung, poetry recited from the logan stone and processions are held, all under the authority of the Chief Bard or Archdruid. Robes of white, blue and green are worn.

Wherever the Gorsedd is held may be seen twelve Gorsedd Stones forming a circle, with a central Maen Llog or Logan Stone.

THE GORSEDD OF THE BARDS—CARRYING THE HIRLAS HORN

This new awareness was reflected in a growing interest in the Royal National Eisteddfod of Wales, which developed new rites and ceremonies, such as the carrying of the Hirlas Hom.

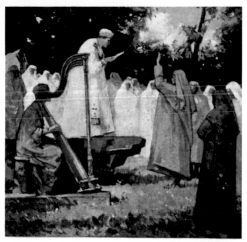

GORSEDD Y BEIRDD TYNGHEDU'R ARWYDDFARDD

THE Gorsedd of the Bards, claimed by some to be derived from druidic rites and ceremonies prevalent in Britain in pre-Christian times, is a picturesque pageant held annually in connection with the Royal National Eisteddfod of Wales.

Druids, ovates, bards, chief musicians, and musicians are initiated ; orations are given, the harp is played and penillion sung, poetry recited from the logan stone and processions are held, all under the authority of the Chief Bard or Archdruid. Robes of white, blue and green are worn.

Wherever the Gorsedd is held may be seen twelve Gorsedd Stones forming a circle, with a central Maen Llog or Logan Stone.

THE GORSEDD OF THE BARDS—THE HERALD BARD TAKING THE OATH

Another was the taking of the oath before the Herald Bard. Both of these early twentieth century postcards come from a series showing the various ceremonies involved in the annual National Eisteddfod.

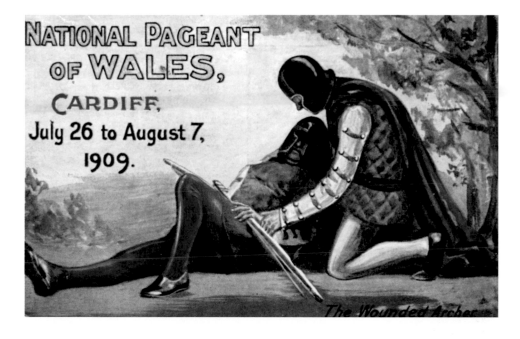

The National Pageant of Wales – held from 26 July to 7 August 1909 was an unashamed celebration of Welsh history and was publicised through the production of a number of postcards – one of which is shown here.

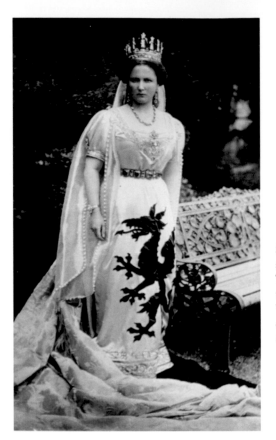

Successive scenes played out twenty-seven episodes from Wales's past. The Marchioness of Bute, wife of the wealthiest man in Wales was created Dame Wales for the duration of the event. She came on to the stage at the beginning of each performance to announce:

We have met to celebrate
The mighty heroes of a bygone time;
To show them as they lived and fought, and died,
And so keep them fresh in memory . . .

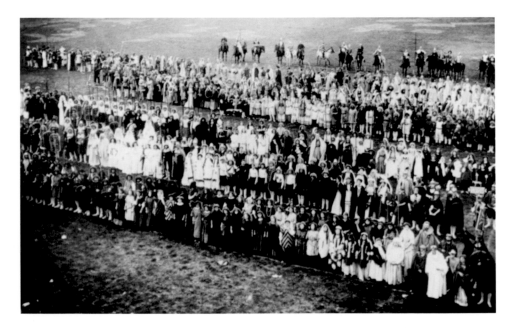

The entire cast of the Pageant came together for the Finale which is shown on this card, the last one in the set.

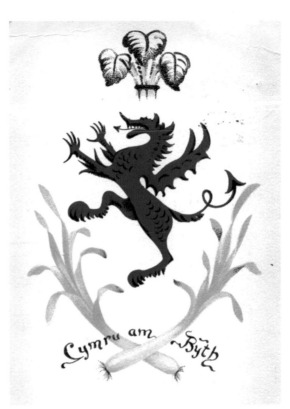

This sense of Welsh nationhood and distinct cultural identity manifested itself in a range of postcards. Here the symbols of Wales appear together on one card – the Prince of Wales's Feathers; the dragon of Cadwaladr and the leek.

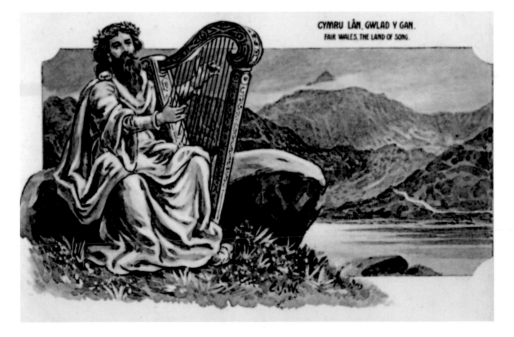

Another, showing a bard playing the harp in Snowdonia, lauds Wales as 'The Land of Song'. The style of the illustration on this card does seem to accentuate Wales's reputation as a land of myths and legends.

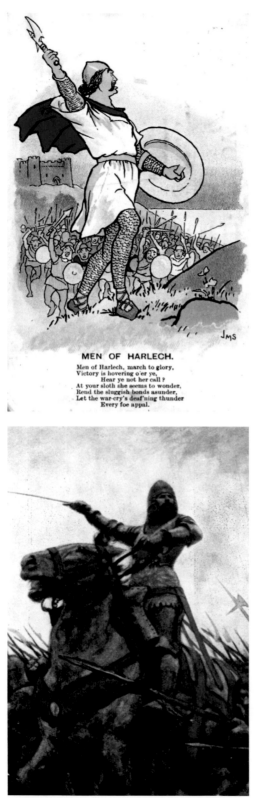

MEN OF HARLECH.

Men of Harlech, march to glory,
Victory is hovering o'er ye,
 Hear ye not her call ?
At your sloth she seems to wonder,
Rend the sluggish bonds asunder,
Let the war-cry's deaf'ning thunder
 Every foe appal.

Another series of cards, published by the Western Mail in Cardiff, is devoted to patriotic songs, this card featuring 'Men of Harlech', a stirring song of resistance.

Other postcards show Welsh heroes. This card features one hero of old – Owain Glyndŵr. From 1400, he led an insurrection that led to him being declared king of a free Wales at Machynlleth, where he held the first Welsh Parliament. His successes meant he was able to lead Wales for almost ten years as an independent nation.

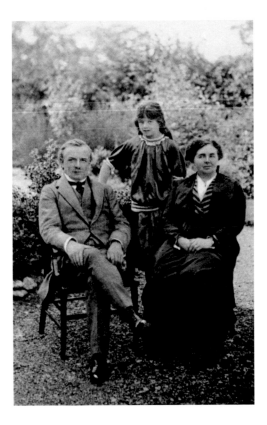

David Lloyd George and his family appear on this postcard. It is one of a series produced to raise money for British troops in the Great War. Lloyd George was Minister of Munitions at this time, becoming Prime Minister in 1916.

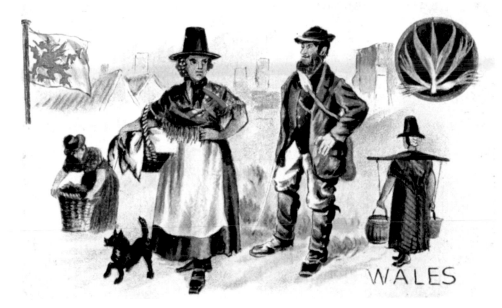

Welsh national costume was a popular topic for postcards, especially as it was seen as rather quaint. This early postcard shows a woman in national costume carrying a basket, a miner, in typical male attire of the time, surrounded by symbols of nationhood including leeks, and the Welsh dragon on a flag.

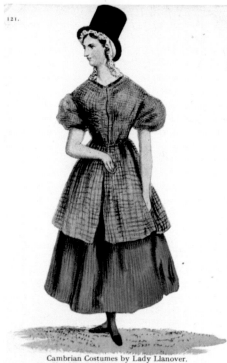

Cambrian Costumes by Lady Llanover.
No. V. Welsh girl in the costume of Gower.

The survival of the distinctive Welsh costume has been attributed to Lady Llanover, who, in the eighteenth century, spent much time collecting and studying variations of the national dress from all parts of Wales. Her drawings are held at the National Library of Wales, who, in the 1920s, produced a series of postcards reproducing those drawings. This example shows the costume from Gower.

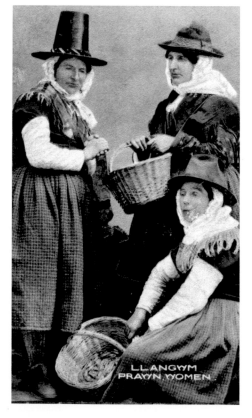

LLANGWM
PRAWN WOMEN

The familiar costume of flannel skirts, knitted or flannel shawls and the black stovepipe hat features on myriad postcards. Publishers vied with each other to produce attractive cards of Welsh women in costume. In this card the Llangwm prawn women, pose with their baskets.

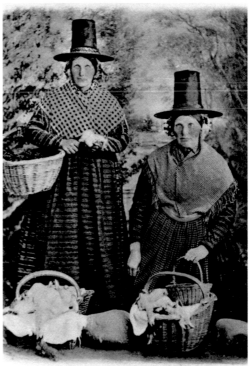

Like the previous card, this card of Welsh peasant women, posing with their baskets of produce, attempt to show working women in national costume. Although shown in tall hats, it is more likely that these women would have worn flatter, harder, hats, as they would have carried baskets on their heads.

Welsh Peasant Women.

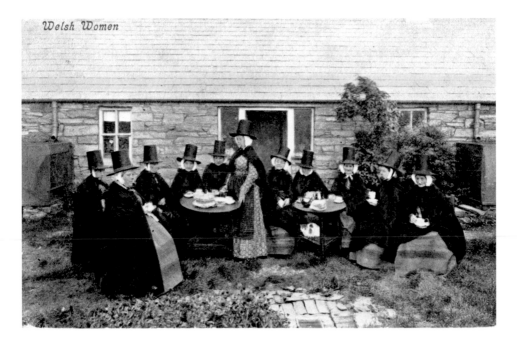

Welsh Women

Postcards showing Welsh women in national costume having tea outside cottages are very common indeed. Judging by the numbers of these postcards that were published, most women in Wales must have spent half their time posing in costume for the camera.

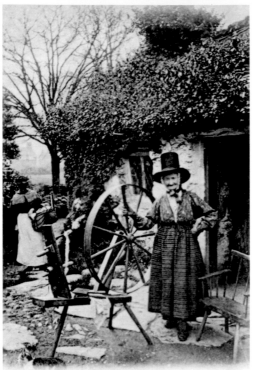

The woman holding her spinning wheel in this black and white card is Ellen Lloyd, who appears on a number of postcards.

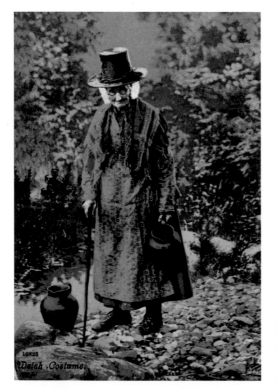

Another frequent postcard celebrity was Catherine Thomas, here fetching water with her earthenware jugs. She was also photographed at her cottage door for other postcards.

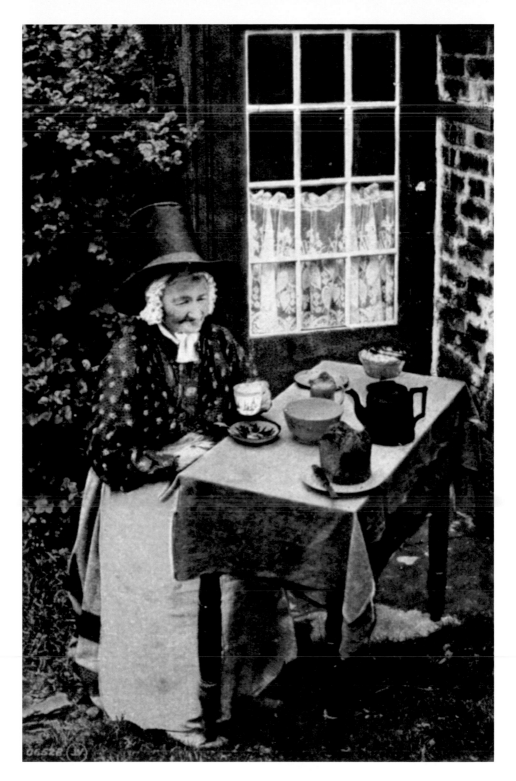

Here we see Ellen Lloyd again, this time taking tea. It is believed that she hailed from Bettws-y-Coed and was, for the time, of quite an advanced age.

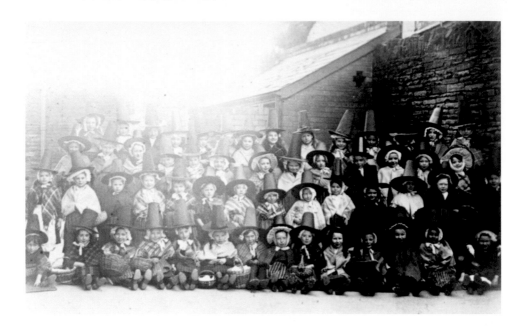

Of course, few Welsh women would have worn the full costume on a daily basis, but dressing up for photographs must have been a frequent occurrence, judging by the number of cards that were on sale. Dressing up for St David's Day, however, is a tradition that continues to the present day. This slightly faded real photo postcard of about 1905 shows the girls of an un-named school dressed to the nines, and wearing what were clearly homemade stovepipe hats.

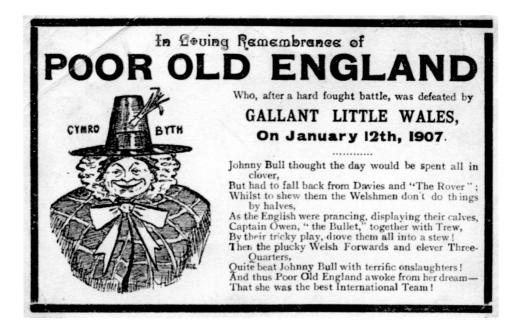

One of the greatest sources of pride for Welsh people was the nation's prowess on the rugby field. This postcard celebrates the famous 1907 Welsh victory over England.

Humourous Welsh Postcards

The survival of the Welsh language was miraculous, given that Wales was subsumed into England for so long. Its survival, however, meant that postcard publishers had plenty of material for the creation of humourous cards in the first quarter of the twentieth century. To the English speaker, the tongue-twisting nature of Welsh caused considerable mirth. Place-names, especially, were a target for the postcard comedians.

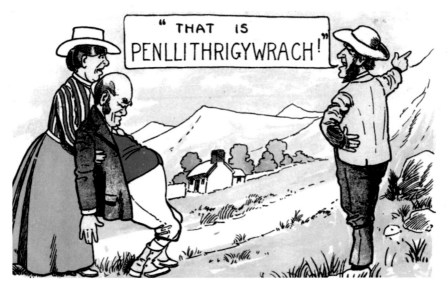

Faced with Penllithrigywrach the traveler falls into a dead faint. This village is situated near Conwy in North Wales.

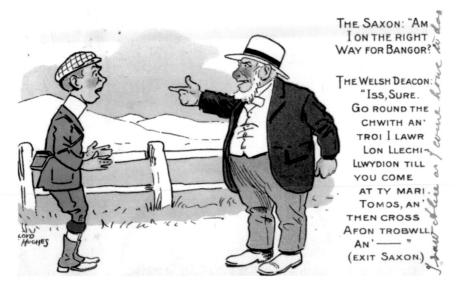

The Saxon on his way to Bangor just gave up! It was not unusual to see an Englishman referred to as a Saxon, but the Welsh deacon was also a stereotype – to be a deacon of the chapel was to be respected; to be seen as a sober, upright member of the community.

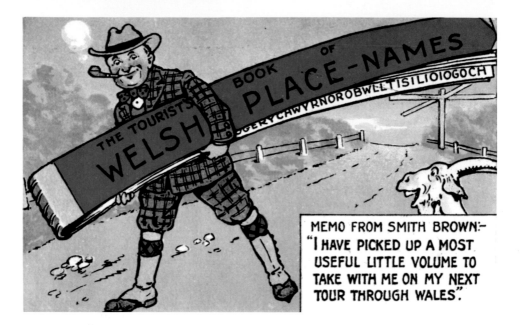

Just carrying the book of place-names proves a problem for another visitor.

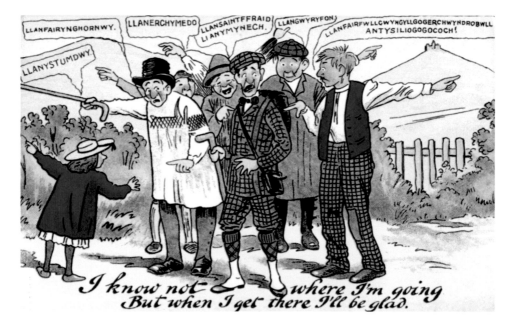

Incomprehensible names in every direction for the Edwardian rambler, including Llanfairpwllgw-yngyllgogerchwyrndrobswlltysiliogogogoch, the longest place-name in the British Isles, and one of the longest in the world.

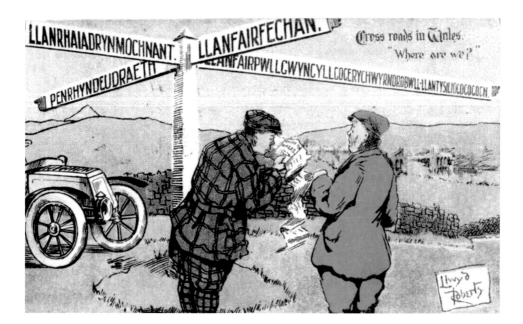

This lengthy name appears on numerous postcards, including this one showing confusion at a crossroads.

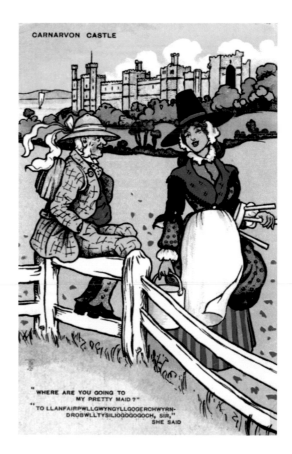

Here it is again on a card featuring Caernarvon Castle. Once again, an English rambler has the good fortune to meet a native – this time a pretty milkmaid in national costume.

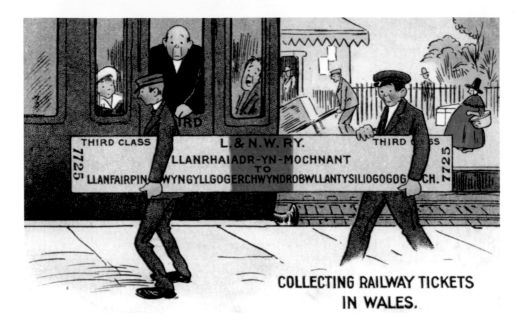

Railway stations, however, gave the postcard publishers real scope, as they could make fun of collecting tickets.

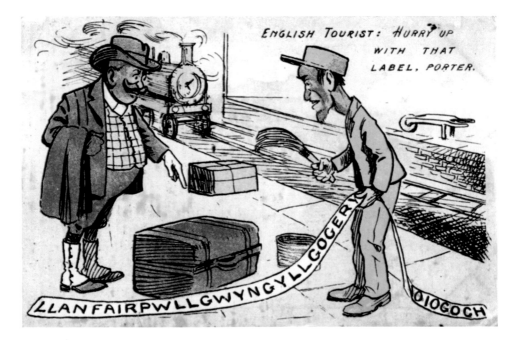

Applying baggage labels.

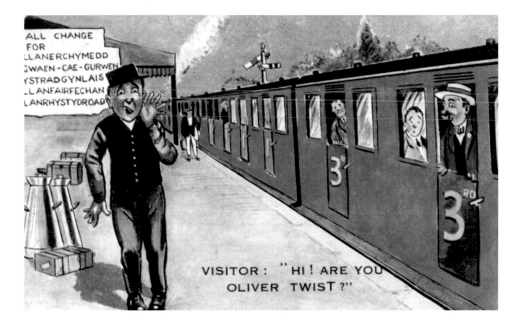

Announcers with pronunciation problems.

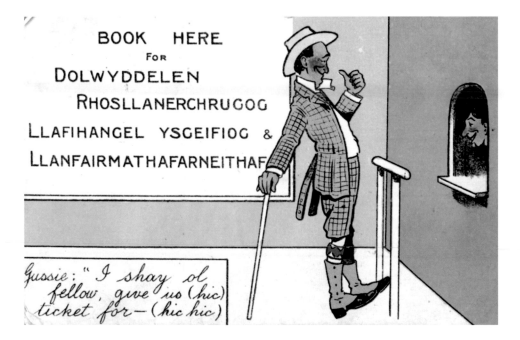

And travellers trying to book their tickets. This example shows a drunken visitor attempting to pronounce a long Welsh place-name.

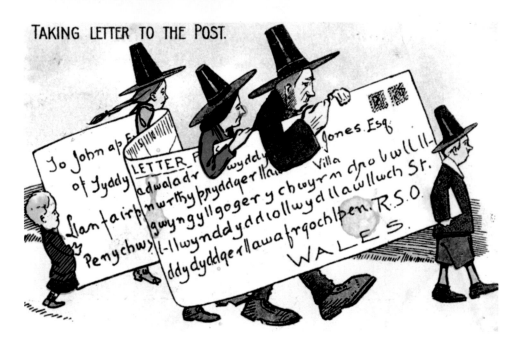

TAKING LETTER TO THE POST.

Taking a letter to the post box was seen as a family outing. In this case the family does seem to be particularly glum.

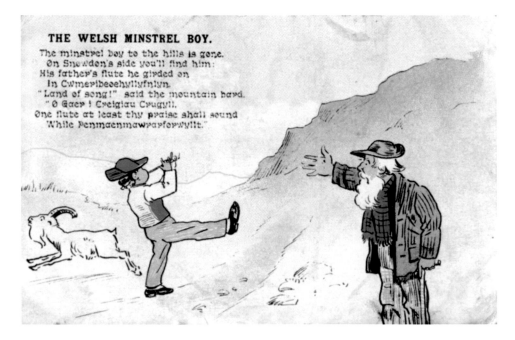

THE WELSH MINSTREL BOY.

The minstrel boy to the hills is gone,
On Snowdon's side you'll find him:
His father's flute he girded on
In Cwmeribeoehyllyfnlyn.
"Land of song!" said the mountain bard,
"O Gaer ! Creiglau Crugyll."
One flute at least thy praise shall sound
While Penmaenmawrarforwyllt."

Variations on popular songs, to include complicated place-names, appeared on some cards, such as 'The Welsh Minstrel Boy'

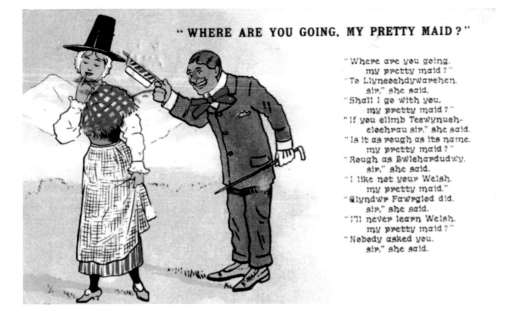

" WHERE ARE YOU GOING, MY PRETTY MAID ? "

" Where are you going,
 my pretty maid ? "
" To Llyneehdywarehen,
 sir," she said.
" Shall I go with you,
 my pretty maid ? "
" If you climb Teewynueh-
 clochrau sir," she said.
" Is it as rough as its name,
 my pretty maid ? "
" Rough as Bwlehardudwy,
 sir," she said.
" I like not your Welsh,
 my pretty maid."
" Glyndwr Fawrgied did,
 sir," she said.
" I'll never learn Welsh,
 my pretty maid ? "
" Nobody asked you,
 sir," she said.

And 'Where are you going, my pretty maid?' Pretty Welsh girls in national costume do appear quite often on the postcards of the time.

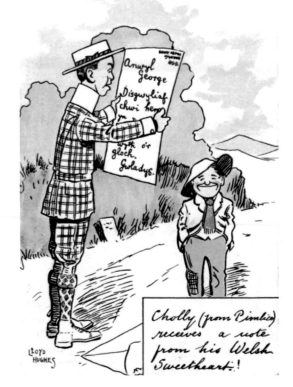

Romantic Englishmen attempting to woo exotically beautiful Welsh-speaking girls appeared on a number of cards. Cholly (from Pimlico) faced a problem with a note written in Welsh.

Cholly (from Pimlico) receives a note from his Welsh Sweetheart !

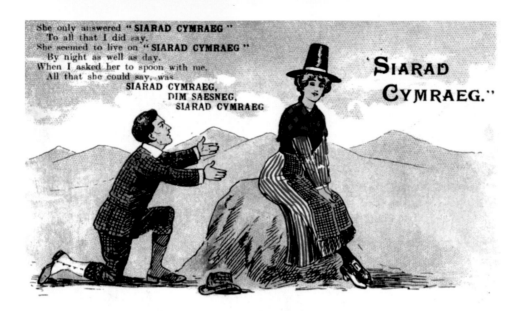

Another fellow found spoken Welsh a problem, although he was prepared to remove his hat and get down on one knee.

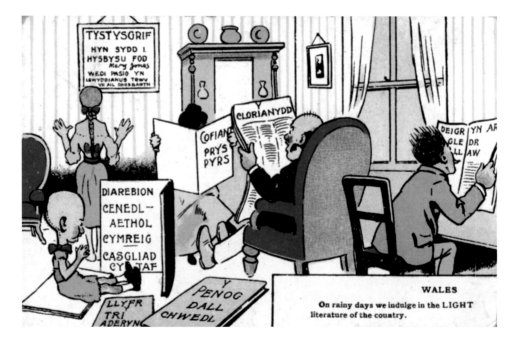

Welsh language books and newspapers featured on this card. There seems to be a suggestion here that the Welsh must be very clever to be able to read and write their own language.

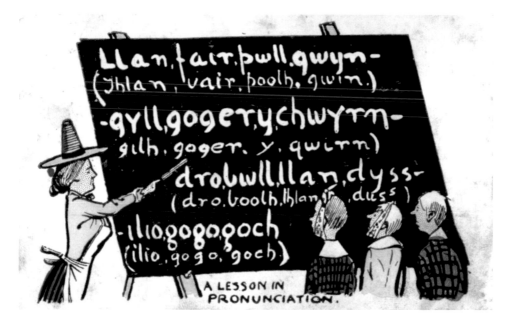

Pronunciation was also something of a problem for those unfamiliar with Welsh. Here a Welsh lesson leads to jaw ache for the students.

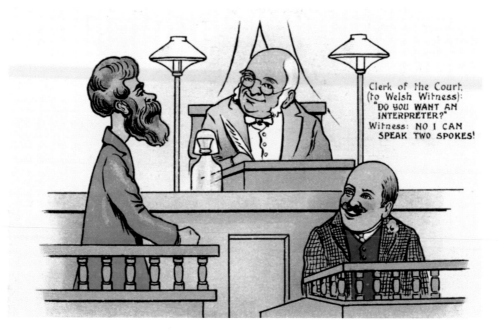

Those Welsh people who spoke both Welsh and English made an impact on postcards too, with the Welsh witness in Court who could 'speak two spokes!'.

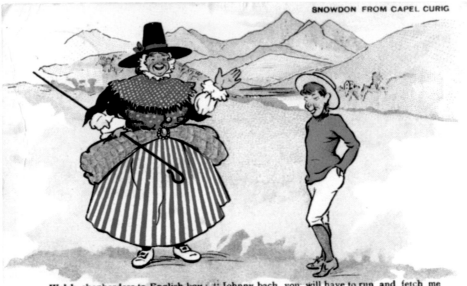

Welsh shepherdess to English boy : " Johnny bach. you will have to run and fetch me up the ships, not ships that goes on wat-ter, but ships that goes pittar. patter, on the grass,

The Welsh accent when speaking English gave rise to some confusion, such as the mix-up with 'ship' and 'sheep' featured on this card.

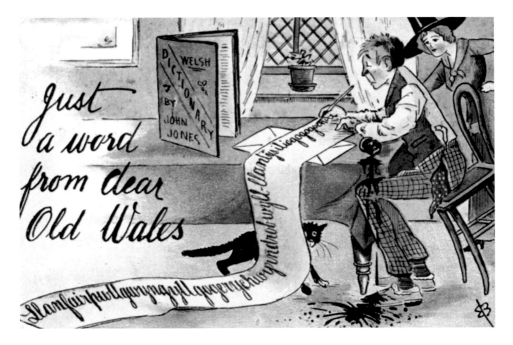

Writing Welsh words was seen to require some effort and a lot of ink!

There were always those handy phrases that a tourist would need when in Wales. This card is from a series by the prolific postcard artist Lloyd Hughes.

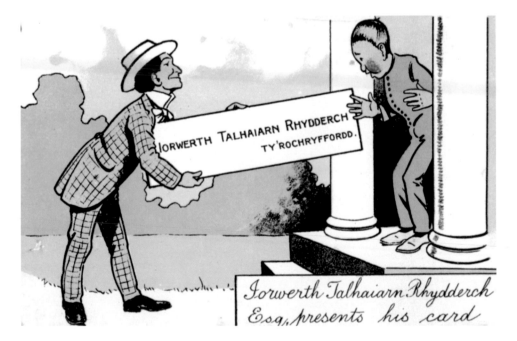

Personal names were another area that gave rise to comic postcards. Here Iorwerth Talhaiarn Rhydderch presents his necessarily large card.

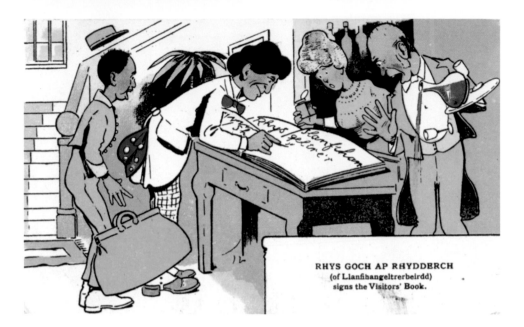

In a nearby hotel. Rhys Goch ap Rhydderch of Llanfihangeltrerbeirdd signs the Visitors' Book.

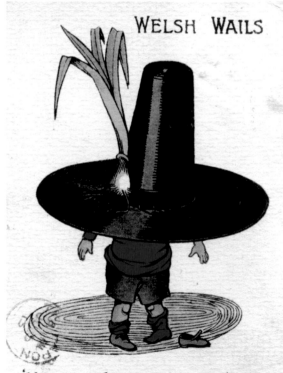

From the 'Welsh Wails' series. Cadwaladr Iorwerth ap Ianto ap Shenkin of Cwmgwylltcwmhir could not get out of his large Welsh hat.

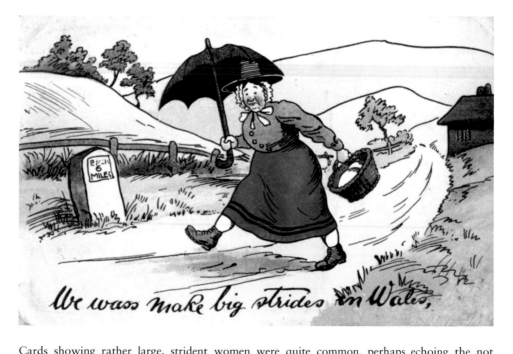

Postcards featuring caricatures of Welsh stereotypes were readily available, such as the Welsh Bard shown in this card boring an English visitor.

Cards showing rather large, strident women were quite common, perhaps echoing the not unusual view that Wales was a matriarchal society.

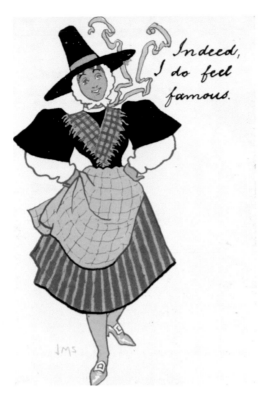

The cards designed by 'JMS', another prolific postcard illustrator, did not all have larger ladies. This card has a young, pretty Welsh girl, reminiscent of the girls on the more romantic Welsh cards we have already seen.

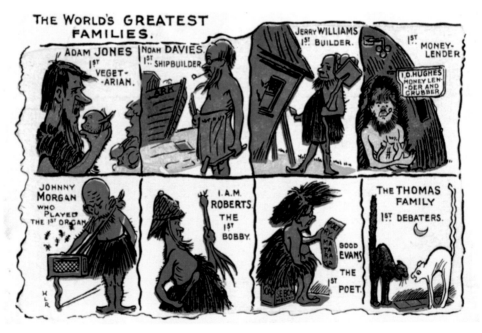

Another area that fascinated postcard publishers was that of family names in Wales. This card, with its Biblical references, highlights the fact that some surnames occur frequently in Wales. Jones, Davies, Williams, Hughes, Morgan, Roberts, Evans and Thomas feature on the card, all of which are amongst the more commonly found surnames.

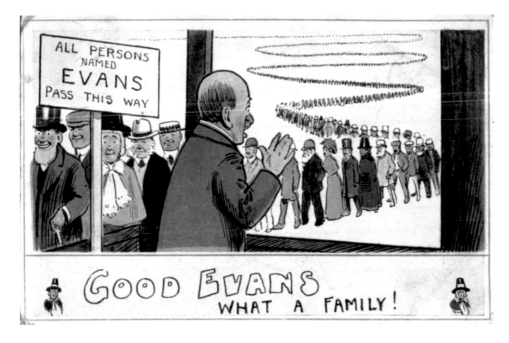

Individual cards were devoted to a particular surname. This card supports the view that Wales had many families with the surname Evans.

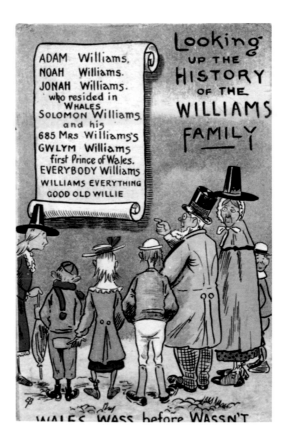

The Williams family name is treated similarly on this card, again with its Biblical references.

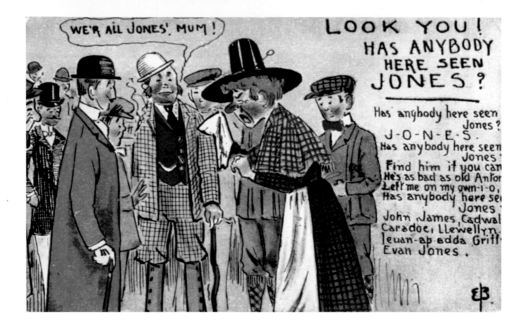

Here, the Jones family are in the spotlight. It seems that the artist was trying to show how Jones's can be found all over the world, as there is a caricature Englishman and a caricature Irishman in the group.

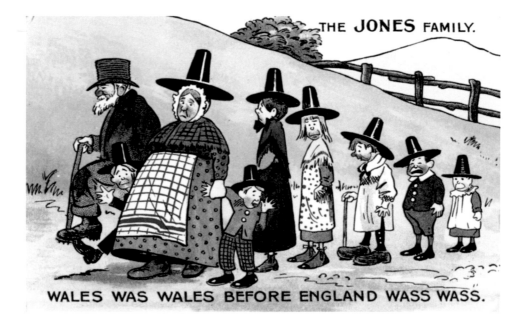

This second Jones family postcard also bears the legend 'Wales was Wales before England wass wass.' This phrase appears on a number of comic postcards, and alludes to the longevity of Welsh culture compared to that of England.

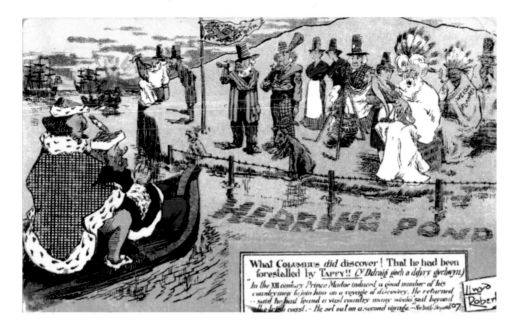

This card, which shows Columbus arriving in a New World already populated by Welsh people, refers to the twelfth century Welsh Prince Madoc, who reputedly sailed beyond Ireland for many weeks, and discovered a vast new country.

"IT'S JUST 'L' DOWN HERE!"

Before leaving this section, I must, of course, feature at least one card that alludes to the reputation that Wales has for rainfall!

A tourist's view of Wales

The early years of the twentieth century saw a boom in tourism in Wales. Tourists were drawn by the spectacular scenery, the beautiful beaches and the resorts that had grown up around them, and of course, the sense that they were somewhere different. The language was unfamiliar, as were the place-names. History seemed close with the great castles built by the English kings, and in the south, the industries that had grown up since the Industrial Revolution. To visit Wales was to experience the exotic close to home.

North Wales

In the Edwardian period North Wales attracted large numbers of visitors. The open countryside, spectacular mountain scenery and the coastal resorts were easily accessible from Liverpool, Manchester and the industrial conurbations of Lancashire, Yorkshire and the Midlands. The area was well-served by railway companies, and there were plenty of hotels and guest houses.

Postcard publishers were quick to realise the potential that this tourist trade created, and many thousands of postcards were sold. Even today, any general collection of Welsh postcards will probably be dominated by cards from North Wales, as they are much more plentiful than those from other areas.

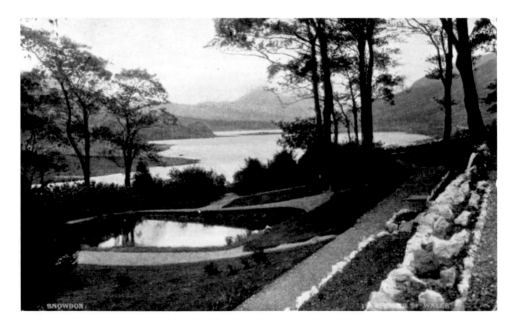

The Cambrian Mountains dominate the north-west corner of Wales, and Mount Snowdon dominates them. Many postcards of the area were published, including general views such as this.

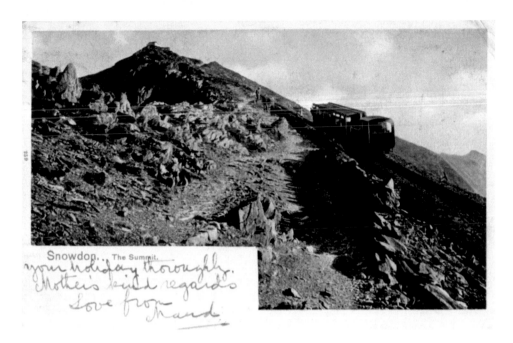

Snowdon. The Summit.

your holiday thoroughly.
Mother's kind regards
love from
Maud.

Getting to the top of Snowdon was made easier by the Snowdon Mountain Railway, which enabled visitors to ride to the summit. This is an early undivided back postcard.

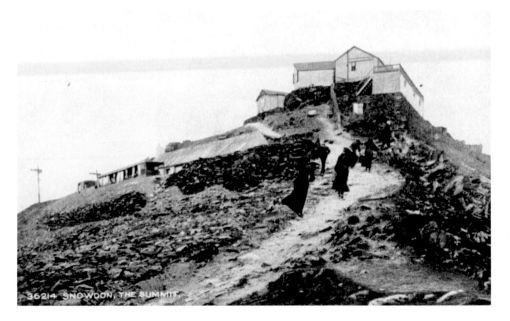

36214 SNOWDON, THE SUMMIT

At the summit there was a railway station and a café.

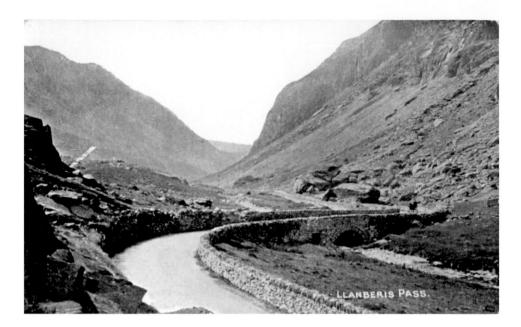

To the east of Snowdon, the Llanberis Pass allowed travellers access to Llanberis and Caernarvon from Bettws-y-Coed. There are a number of passes through the mountains of North Wales and every one of them appear on postcards. It is not practicable to show them all.

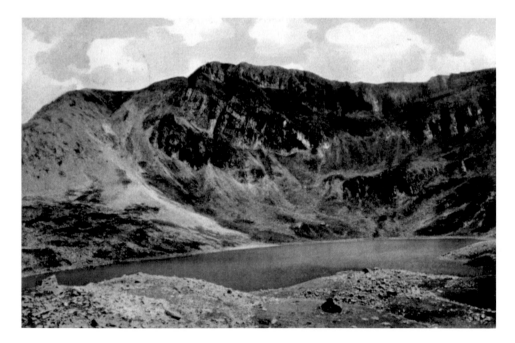

Cader Idris, lies at the southern edge of the Cambrian Mountains, near Dolgellau.

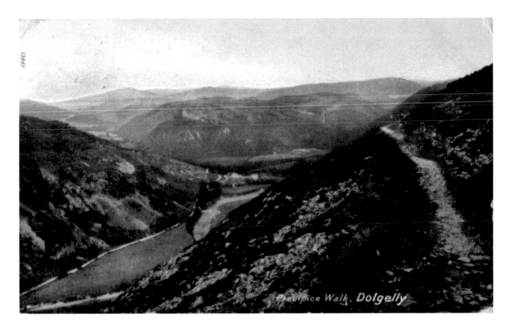

From the aptly named Precipice Walk, near Dolgellau, anyone on foot would have a panoramic view of the mountains and valleys.

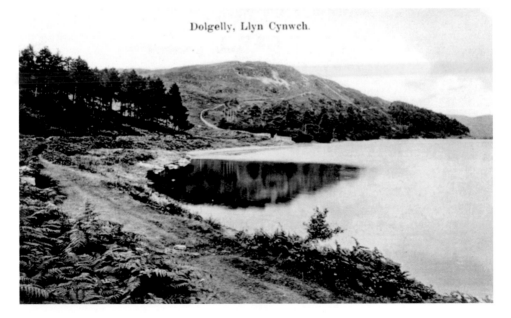

The photographer must have been the only visitor on the day he took this view of Llyn Cynwch, near Dolgellau, one of the many lakes in Snowdonia.

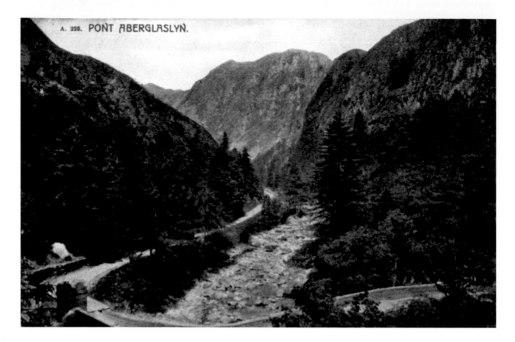

With many rivers running through Snowdonia, there are many bridges, and these too proved popular with postcard publishers. Pont Aberglaslyn, in the Aberglaslyn Pass is just one. 'Pont' is the Welsh word for 'bridge'.

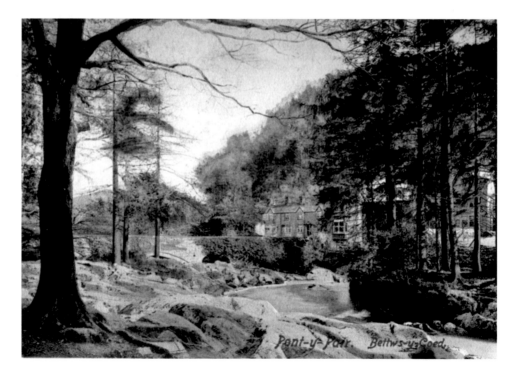

Look closely, and you can just see Pont-y-Fair, near Bettws-y-Coed, in this view.

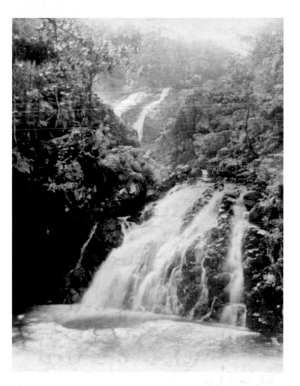

Rhyader du Tyn-y-Groes, Barmouth.

Waterfalls, too, abound in Snowdonia, and postcard publishers were attracted by their spectacular beauty. This card shows the waterfall at Barmouth.

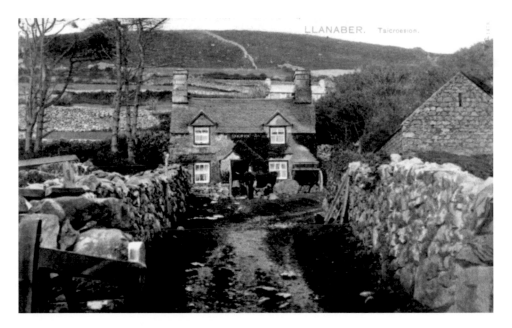

Llanaber lies just to the north of Barmouth, and this locally published postcard shows Talcroesion, a small farmstead so typical of the area. Notice the dry stone walls, the stone built barn and rough track.

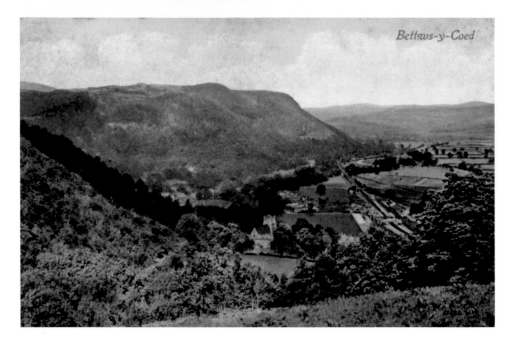

This panoramic view shows Bettws-y-Coed nestling amongst the trees in it valley. The railway line and the railway station can be seen on the righthand side of the scene.

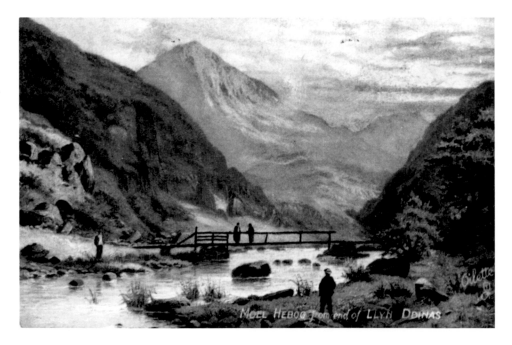

MOEL HEBOG from end of LLYN DDINAS

The mountain Moel Hebog stands above Llyn Ddinas, just the north of Beddgelert. This an 'Oilette' card by Tucks and reproduces a painting by E. Longstaffe.

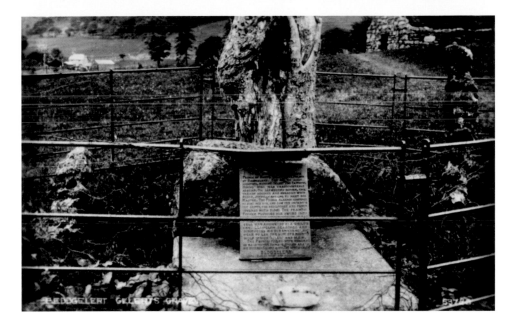

Beddgelert is possibly the only town named after a dog. The legend states that Llewellyn, Prince of North Wales went hunting one day, leaving his dog Gelert behind to guard his baby son. In his absence, Gelert fights and kills a marauding wolf, which leaves him bloodied. When Llewellyn returns, he sees no sign of his son, but there is Gelert with blood trickling from his mouth. Angered, Llewellyn slays the dog, only then to find his baby son amongst the blankets. Full of remorse, Llewellyn buries his faithful dog with due ceremony, and names the place Beddgelert in his honour. Gelert's grave, with a plaque outlining the story, can still be seen in a field near the town.

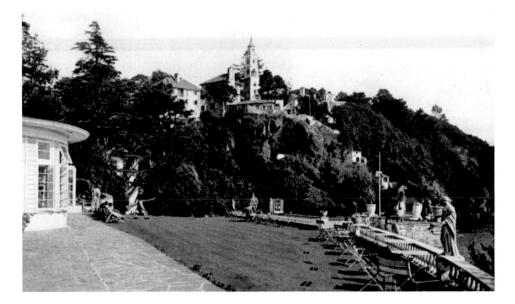

West of Beddgelert lies the Lleyn Peninsula, and on the southern coast can be found Portmeirion. Originally called Aber Ia, the site was bought in 1925 by the architect Clough Williams-Ellis who developed the fantasy village which later featured in the TV series *The Prisoner*.

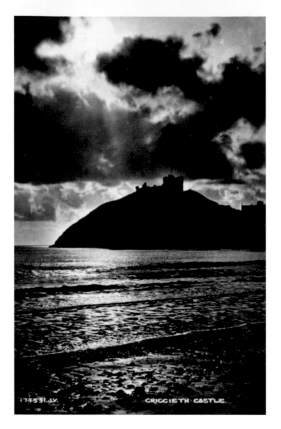

Also on the southern coast can be found Criccieth Castle, shown here in an atmospheric evening view.

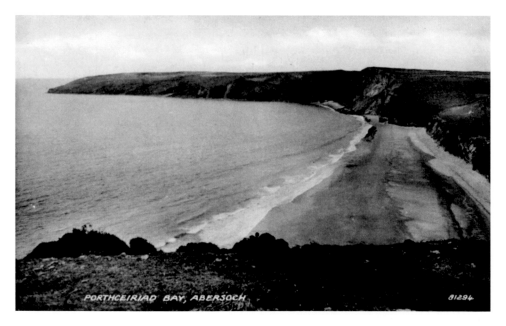

Abersoch lies to the west of Pwllheli and was popular with those who wanted a quieter, 'away from it all' holiday by the sea.

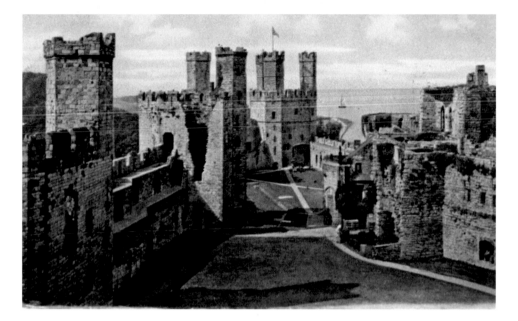

The south-western end of the Menai Straits is guarded by Caernarvon Castle, perhaps the most potent symbol of the success of Edward I in subjugating the rebellious Welsh.

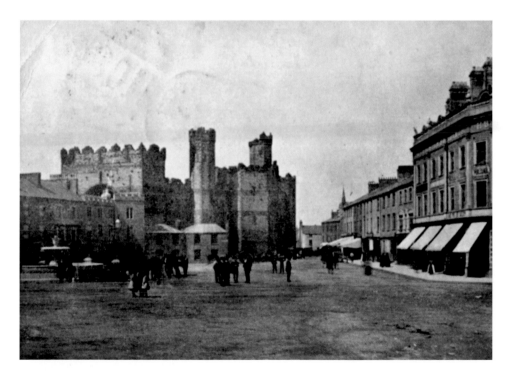

The castle, which was the setting for the Investiture of Prince Charles as Prince of Wales in 1969, dominates the town of Caernarvon. This early sepia undivided back postcard shows the broad expanse of Castle Square.

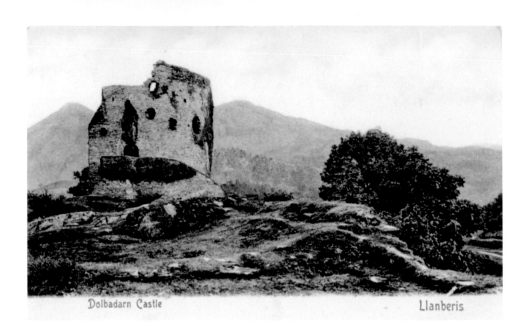

Dolbadarn Castle Llanberis

Inland from Caernarvon lies the small town of Llanberis, near which can be found the remains of Dolbadarn Castle. Built by Llewelyn the Great before 1230, it was abandoned in 1284 after being taken by the English. For twenty years, Llewelyn the Last imprisoned his older brother Owain Goch on the upper floor of the castle.

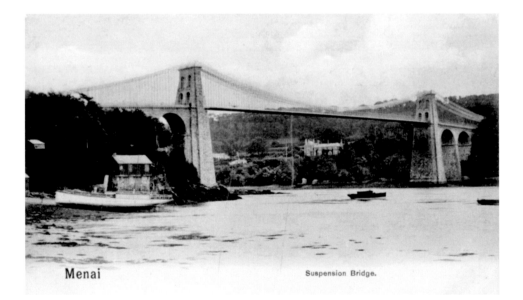

Menai Suspension Bridge.

Another well-known landmark on the Menai Straits is the Menai Suspension Bridge, linking mainland Wales with the Isle of Anglesey.

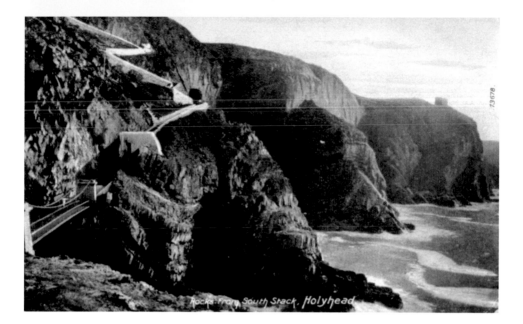

Anglesey comprises several islands, the main two being Anglesey itself, and Holy Island, with the town of Holyhead. At the western edge of Holy Island are the South Stack cliffs, shown on this 1906 postcard.

Menai Straits from
Llanfairpwllgwyngyllgogerychwyrndrobwll-llandysiliogogogoch

| Church | Mary | a hollow | white | hazel | near to | the | rapid | whirlpool | Church | Saint's name | cave | red |

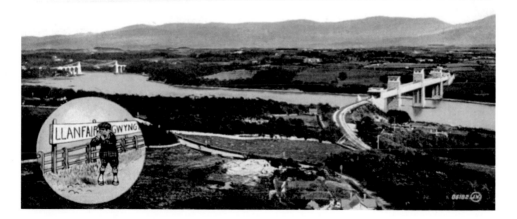

Overlooking the Menai Straits, Llanfairpwllgwyngyllgogerychwyrndrobwllllandysiliogogogoch has the longest place-name in the British Isles. This view shows the Menai Suspension Bridge in the background, and in the foreground the Britannia Bridge which carries the main railway line across the straits.

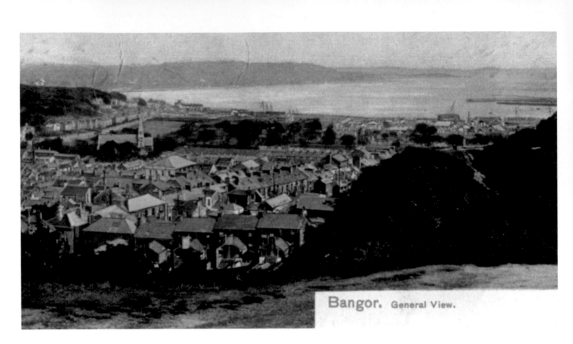

Bangor. General View.

At the north-eastern end of the straits stands the city of Bangor.

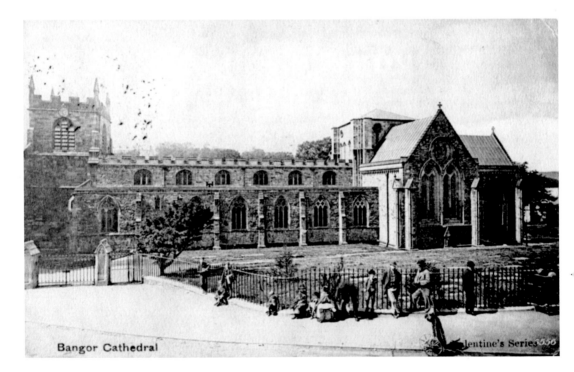

Bangor Cathedral

Valentine's Series 556

The cathedral at Bangor is dedicated to the Celtic St Deiniol. Its position meant that it suffered repeatedly during the tumultuous medieval period and was rebuilt several times. The current building is a Victorian renovation undertaken by Sir George Gilbert Scott that obscured most of the earlier building work.

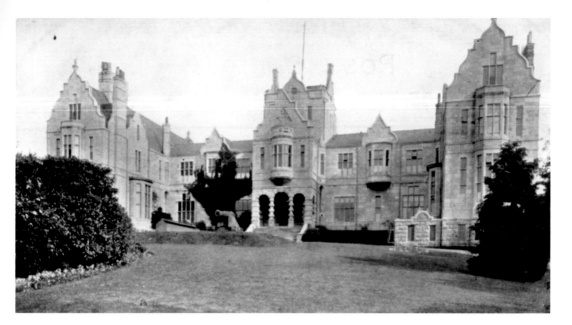

Teacher training was the main purpose of the Bangor Normal College, which is now part of Bangor University.

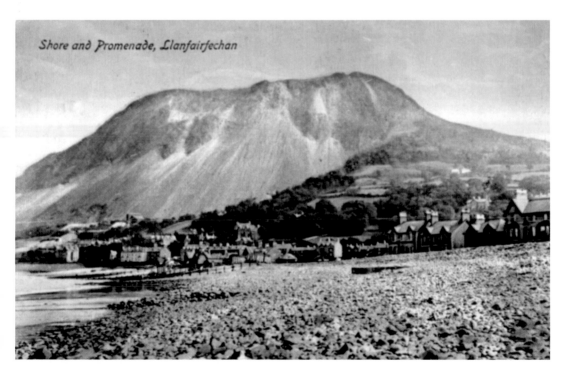

Shore and Promenade, Llanfairfechan

The road from Bangor to Conwy passes through the picturesque community of Llanfairfechan.

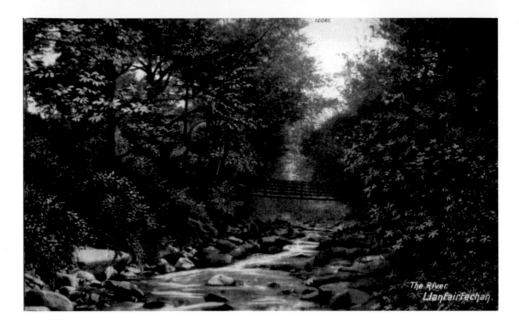

Pretty scenes such as this of the river near Llanfairfechan were standard fare for postcard publishers, for Wales was rich in such places.

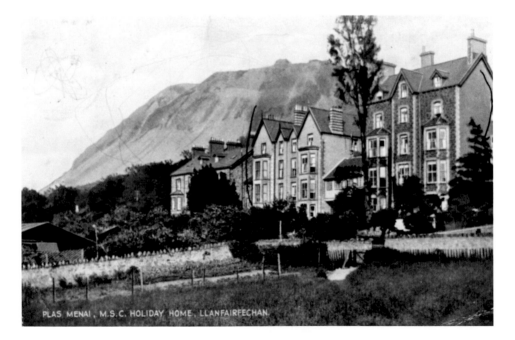

A common feature of several Welsh seaside towns were holiday homes or convalescent homes run by English organisations for the benefit of workers from the industrial heartlands. On this slightly later postcard can be seen Plas Menai, the MSC Holiday Home at Llanfairfechan.

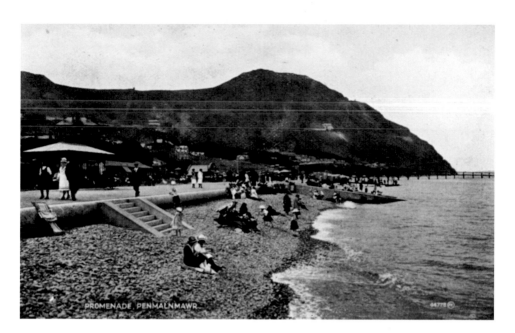

Penmaenmawr is one of the smaller North Wales seaside resorts, but has a promenade amongst its attractions.

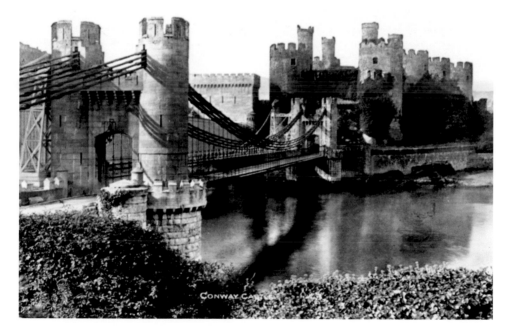

At Conwy stands another of the great castles of Edward 1. The arrival of the railway in the nineteenth century entailed building a bridge to cross the river adjacent to the castle. The bridge was built with crenellated towers so that they would blend in with the castle.

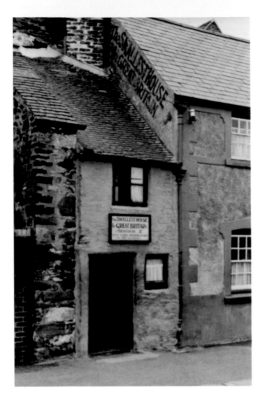

The smallest house in Great Britain can be found at Conwy. It has been the subject of many postcards over the years, showing both the exterior and the interior.

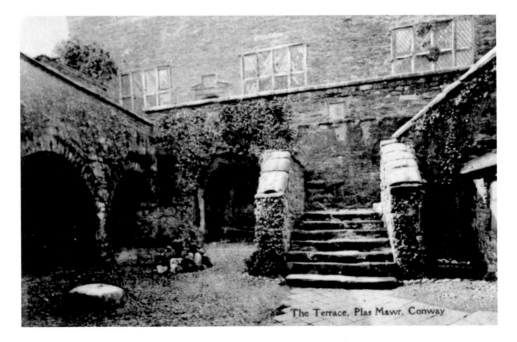

The Terrace, Plas Mawr, Conway

Plas Mawr is considered to be the finest surviving Elizabethan town house anywhere in Britain. It was built between 1576 and 1585 for Robert Wynn, a wealthy local merchant. The house was a popular subject for postcards, this one showing the Terrace.

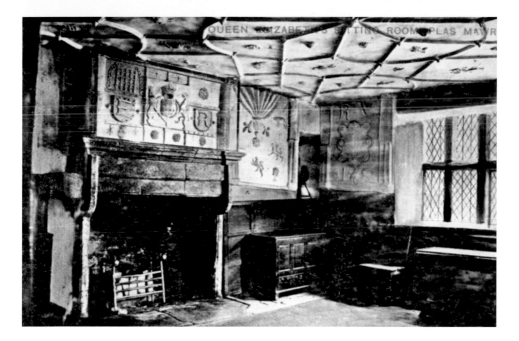

Even in the Edwardian period the house was a popular attraction, and visitors could see rooms furnished as accurately as possible, such as Queen Elizabeth's Sitting Room, shown on this card.

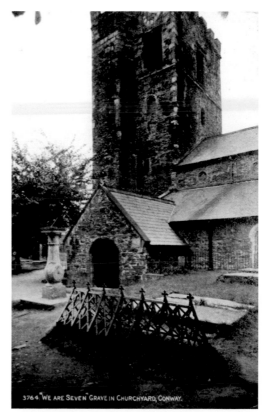

Conwy's parish church, St Mary and All Saints, was once the abbey church of the Abbey of Aberconwy. The Abbey was removed by Edward I to allow the building of Conwy Castle, and the church became a parish church. In the churchyard is the grave of seven brothers and sisters – the 'We Are Seven' grave which some believe inspired William Wordsworth to write his poem of the same name.

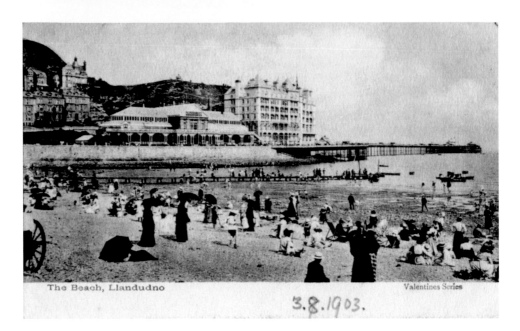

The Beach, Llandudno Valentines Series

3.8.1903.

The smooth lines of the North Wales coast are broken only by the peninsula on which stands Llandudno, tucked between Great Orme Head and Little Orme Head. Llandudno is a typical Victorian seaside resort, with a pier and a promenade.

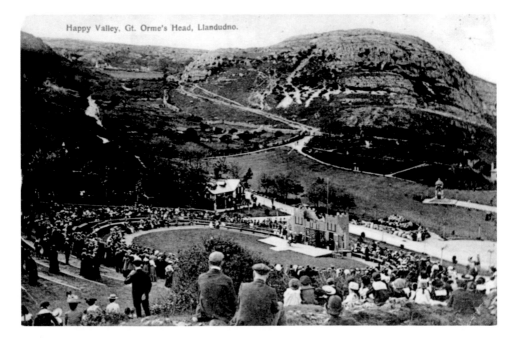

Happy Valley, Gt. Orme's Head, Llandudno.

The natural amphiteatre of Happy Valley provides a venue for outdoor entertainments of all kinds, such as pierrot shows.

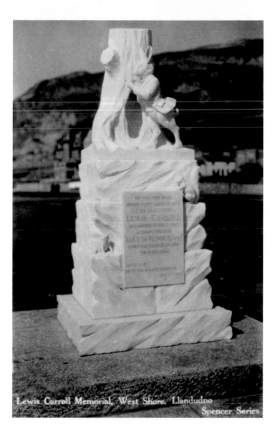

Lewis Carroll used to walk along the shore of Llandudno Bay with Alice Liddell, and so was inspired to write Alice in Wonderland. A memorial to the writer stands on West Shore, which was unveiled by David Lloyd George in 1933.

Lewis Carroll Memorial, West Shore, Llandudno
Spencer Series

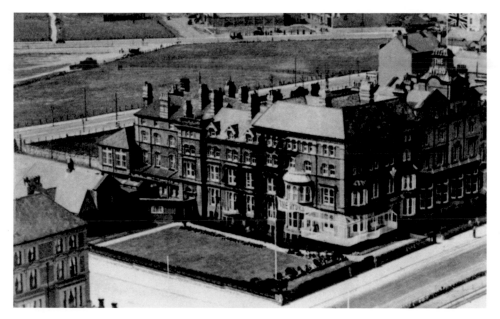

Considered the Queen of Resorts by many, Llandudno has a magnificent row of hotels along the promenade. Most, including The Hydro, were built in the middle of the nineteenth century.

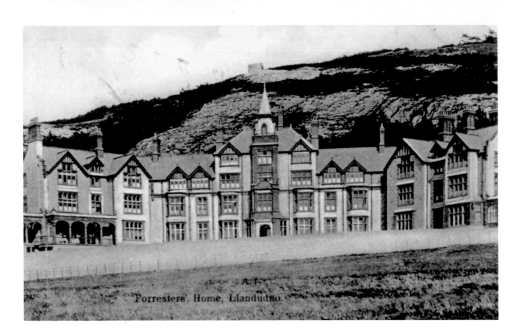

The Forrester's Home, Llandudno. This was another of the convalescent homes that were established in several Welsh seaside resorts.

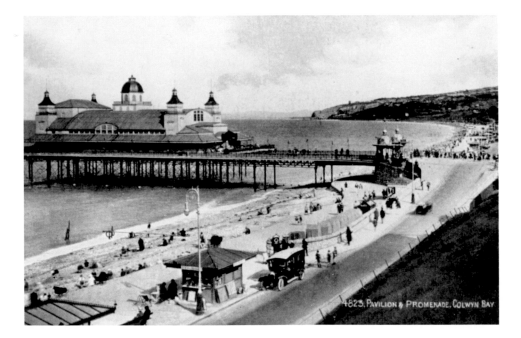

Just a few miles along the coast Colwyn Bay with its pier pavilion, also drew the tourists. Notice the wonderful motor vehicle parked at the roadside.

Woodland scenes gave postcard publishers more pretty scenes for publication. In this case, the postcard reproduces a painting of Pwllycrochan Woods, Colwyn Bay, by A. Netherwood, of Conwy.

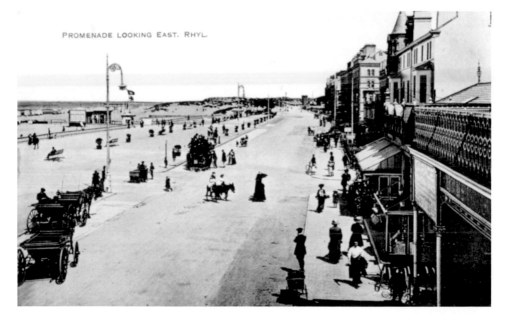

PROMENADE LOOKING EAST. RHYL.

Rhyl, too, is a much visited resort. Horse drawn vehicles feature in this card, but also note the children riding donkeys across the road. The activity on this card makes it more interesting for the collector, who can study the details of dress and transport.

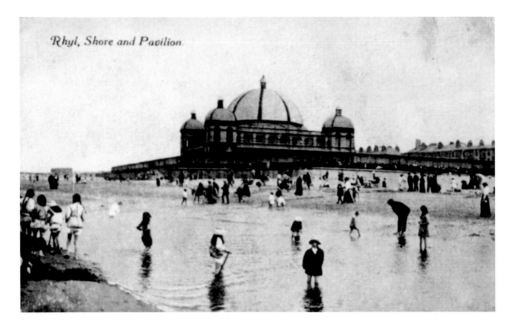

Rhyl, Shore and Pavilion.

Like Colwyn Bay and Llandudno, Ryhl too, has a Pavilion. Keeping one's hat on was important, even when paddling!

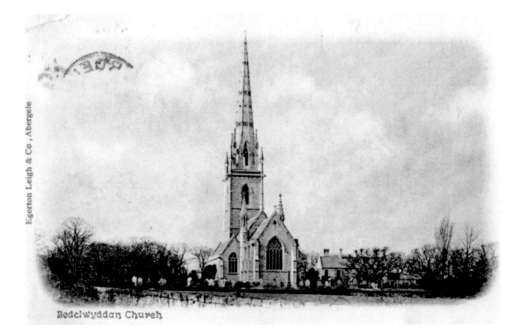

Egerton Leigh & Co., Abergele

Bodelwyddan Church

Inland from Rhyl, the church at Bodelwyddan, with its impressive spire, was popular with postcard publishers.

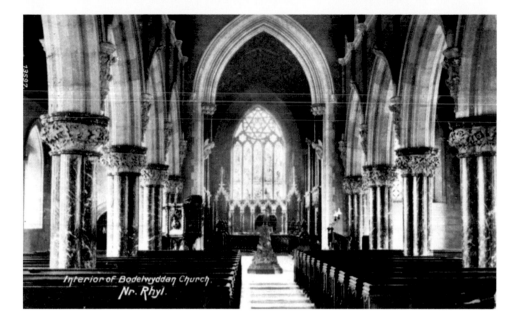

Church interiors are commonly seen on Edwardian postcards. Many of them had been restored in the latter years of the Victorian period, and were deemed fitting topics for postcards. This early postcard shows the interior of Bodelwyddan Church.

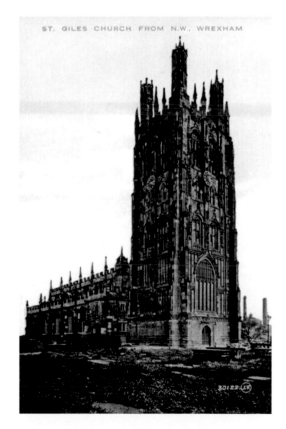

The largest parish church in Wales is the impressive St Giles Church at Wrexham, with its ornate tower. This, however, is less often seen on postcards. Wrexham lies close to the English border south of Chester.

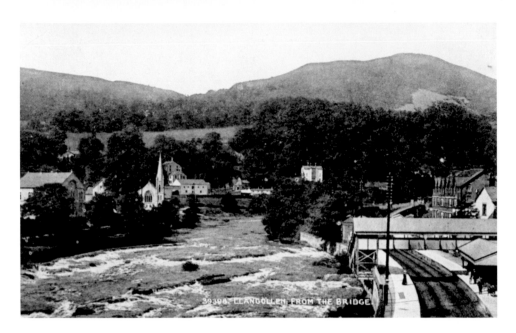

A few miles west of Wrexham lies Llangollen, a town synonymous in many people's minds with Welsh culture, being the home of the Llangollen International Eisteddfod. This often pictured scene shows the railway station almost overhanging the River Dee.

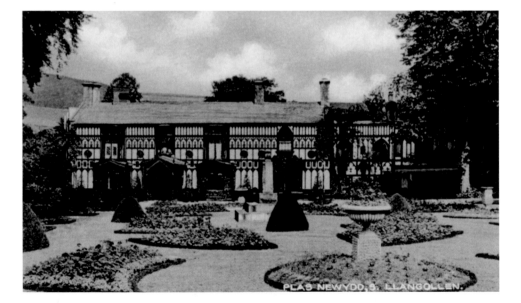

Between 1780 and 1829 Plas Newydd near Llangollen was the home of Lady Eleanor Butler and Miss Sarah Ponsonby. These two were known as 'The Ladies of Llangollen' and were a *cause célèbre* in Regency society having eloped from Ireland to be together.

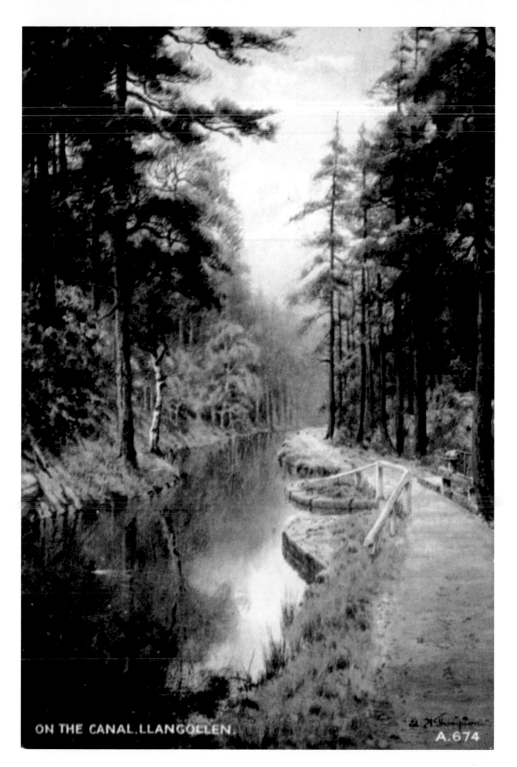

ON THE CANAL, LLANGOLLEN.

A.674

The Llangollen Canal provides yet another opportunity for the charming country scene so beloved of postcard producers. In this case the card reproduces a painting by E. H. Thompson.

Mid Wales

Mid Wales is dominated by the southern range of the Cambrian Mountains, known as 'the Green Desert of Wales'. The highest point, Plynlimon, is the source of the Rivers Severn and Wye. The whole area is characterised by its quiet countryside, where farming is the mainstay of the economy. There are no large centres of population.

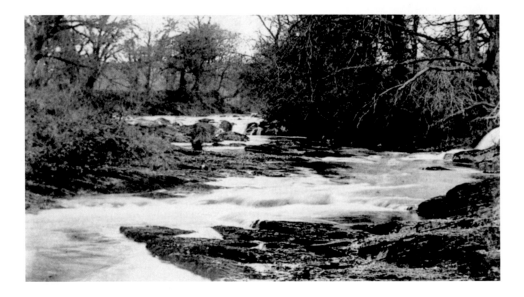

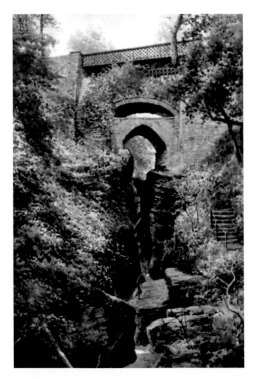

Above:
As has been seen, the rivers of Wales gave postcard publishers many pretty views to reproduce. In this card, the River Rhiw wends it way to the River Severn at Berriew, near the English border.

Left:
Farther to the west, the River Rheidol, another to rise on Plynlimon, heads to the sea at Aberystwyth. As it goes it passes beneath the Three Bridges at Devil's Bridge.

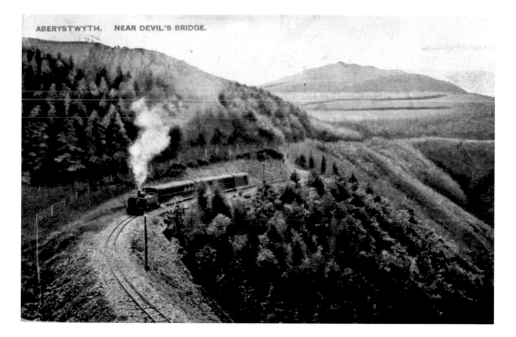

ABERYSTWYTH. NEAR DEVIL'S BRIDGE.

The narrow gauge Vale of Rheidol Railway connects Aberystwyth and Devil's Bridge, and in Edwardian times was a great draw for tourists. Indeed it continues to be popular today. It has the distinction of being the only narrow gauge railway in Wales to have been nationalised as part of British Railways and later British Rail.

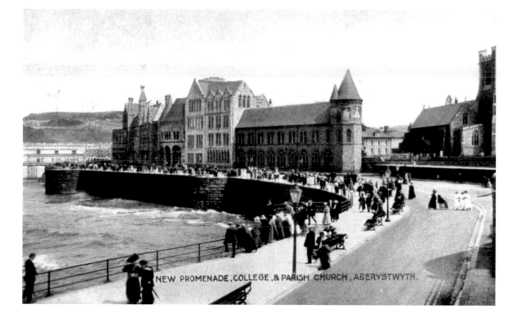

NEW PROMENADE, COLLEGE, & PARISH CHURCH, ABERYSTWYTH.

The University town of Aberystwyth, on the coast of northern Cardiganshire, is the largest town in Mid Wales. Again a lot of activity on this card, as people look over the sea wall at the fairly rough waves. Note the wheelchair-bound person being pushed across the road.

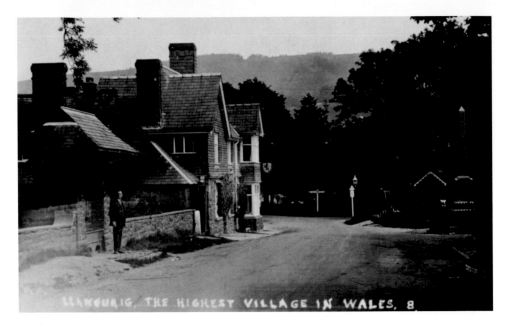

Some 25 miles inland from Aberystwyth, on the River Wye, is Llangurig, the highest village in Wales.

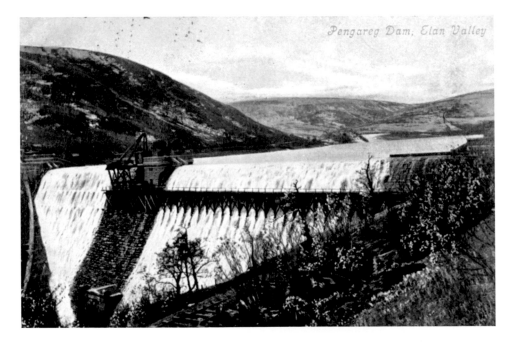

South of Llangurig and west of Rhayader can be found the Elan Valley, where a complex of reservoirs were created in the late nineteenth century to provide water for Birmingham. The Penygarreg Dam holds back the waters of the Penygarreg Reservoir.

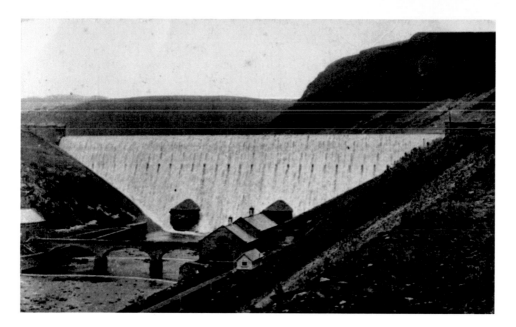

Caban Goch Dam is at the southern end of the Caban Goch Reservoir, and is the most southerly of the dams of the Elan Valley. Begun in 1893, the dam was opened on 21 July 1904 by King Edward VII and Queen Alexandra.

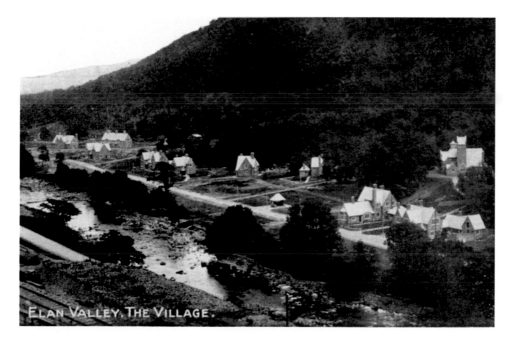

ELAN VALLEY, THE VILLAGE.

Just to the east of the Caban Goch Reservoir lies Elan Village. When the dams of the Elan Valley were being built, over 100 residents of the soon-to-be flooded valley were forced to move. The Corporation of the City of Birmingham even rebuilt their church.

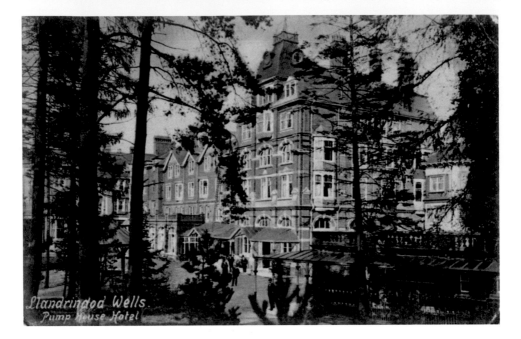

Water plays another role in the life of Mid Wales. Spa waters with healing properties led to the creation of the town of Llandrindod Wells, and postcards of the town were available for those who came to partake of the waters to send home.

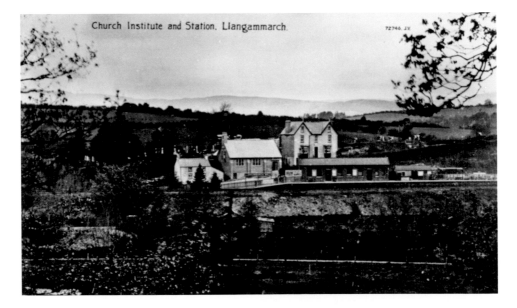

Although on a very much smaller scale than Llandrindod Wells, Llangammarch Wells also catered for those in need of the healing properties of the local water. This postcard shows the railway station, where many of those visitors would have alighted.

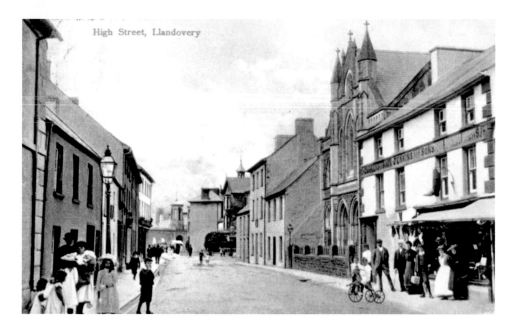

High Street, Llandovery

Further to the west, where Mid Wales merges into West Wales, lies the market town of Llandovery. This early card shows the High Street, and the arrival of the photographer must have been the highlight of the day, as everyone has come out to have a look and pose for the camera.

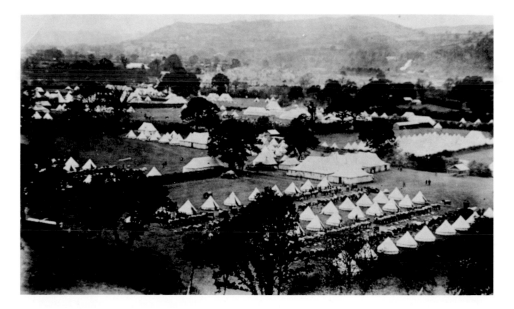

Every county had its Yeomanry, an early version of the Territorial Army, where part-time volunteers trained in various military skills. Annual Camps were a major element of their activities, and this postcard shows the Camp at Llandovery in 1909, although it does not say which county Yeomanry were present.

West Wales

West Wales comprises the counties of Pembrokeshire and Carmarthenshire with the southern part of Cardiganshire. Generally low lying, rich farmland, this part of Wales was also a magnet for tourists. The coastline boasts sandy beaches, isolated coves and a wealth of wildlife.

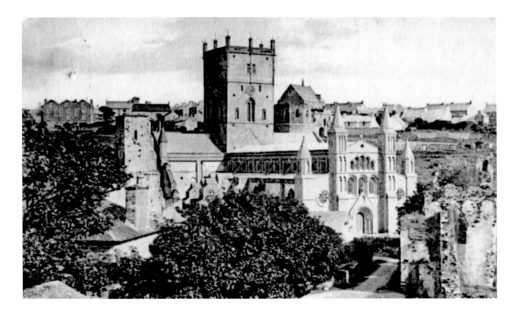

In the far west of Wales can be found Great Britain's smallest city – St David's. The present cathedral dates from 1181, and was built on the site of a monastery founded by St David himself The building has been much altered since, principally by Bishop Gower in the fourteenth century and Sir George Gilbert Scott in the nineteenth century.

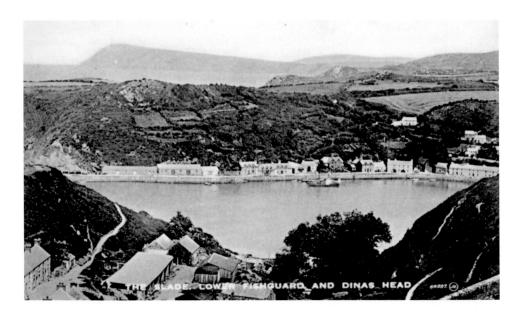

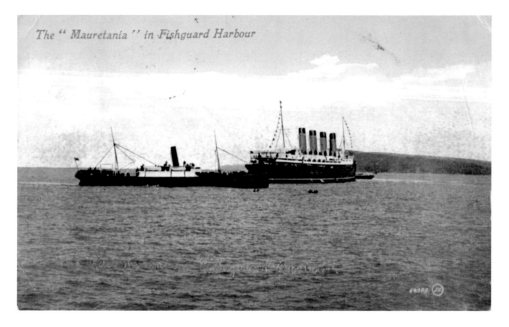

The " Mauretania " in Fishguard Harbour

On occasion, large passenger ships called at Fishguard, including the *Mauretania*.

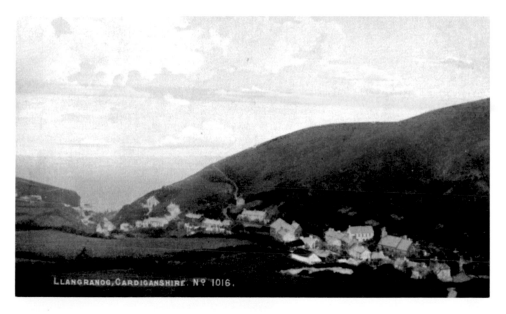

LLANGRANOG, CARDIGANSHIRE. Nº 1016.

Llangranog is typical of many Welsh coastal villages, with the houses tumbling down a narrow valley to the sea.

Opposite below: The port of Fishguard has always been an important harbour, especially as a gateway to Ireland. This postcard shows the Lower Town, with Dinas Head in the background.

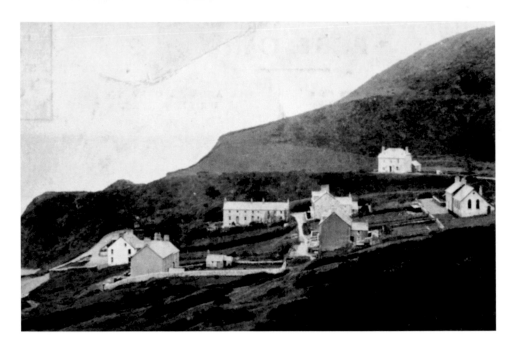

Tresaith is a similar, although much smaller, community.

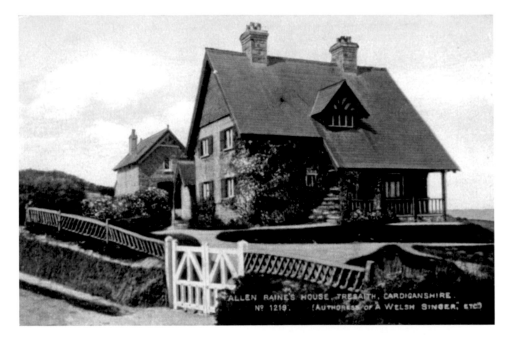

Bronmor, at Tresaith, appears on a number of postcards. It was the home of Allen Raine, the pen name of Ann Adaliza Puddicombe, a prolific novelist from 1894 through to her death in 1908.

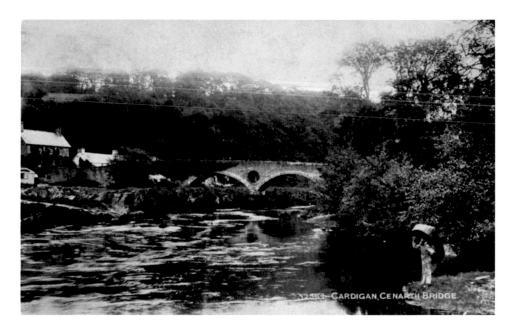

Coracles are synonymous with Wales, and although once common, they are now a rare sight. One river where coracles can still be seen is the Teifi at Cenarth, near Cardigan.

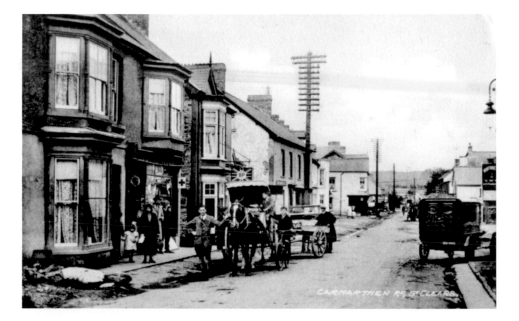

The rural communities of inland West Wales drew fewer tourists, and the postcards that were produced tended to be for local consumption. As a result they were more intimate in character. This view of Carmarthen Road, St Clears is typical, with local people posing, delivery vehicles in evidence, and details of shops and houses clearly seen.

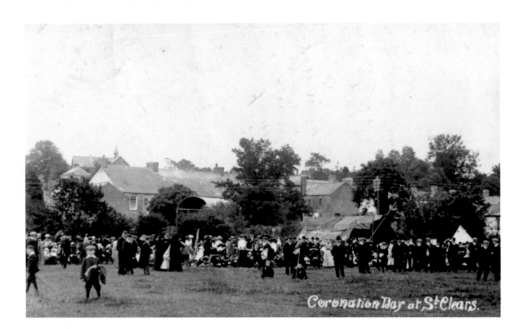

Local events were also recorded, usually by local photographers. Cards such as this one of the 1911 Coronation Day celebrations at St Clears would have been published in small numbers, and are therefore scarce today.

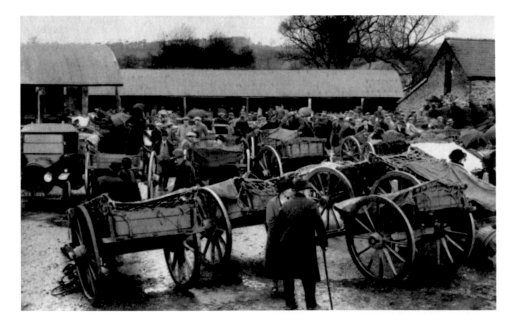

In Llanybyther, Mart Day provided the subject of a detailed and interesting postcard. Lots of carts, lots of people, even one car. Judging by the umbrellas, it must have been a damp day.

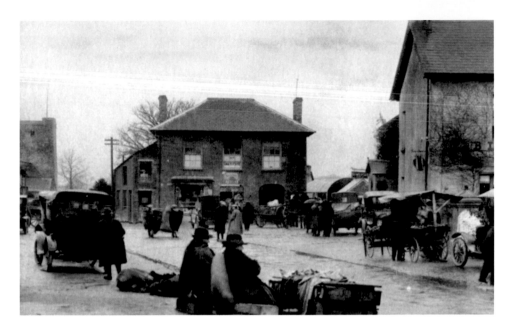

Paired with this postcard of the Market Square at Llanybyther, probably photographed on the same day as the Mart Day card, we get a fascinating insight into life in a small market town in the early years of the twentieth century.

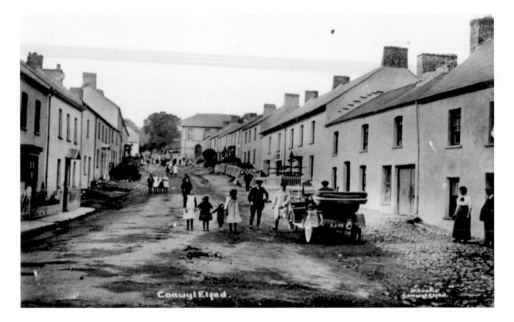

Conwyl Elfed, north of Carmarthen, was another small town where the local photographer could draw quite a crowd when he decided to go out to take some photographs.

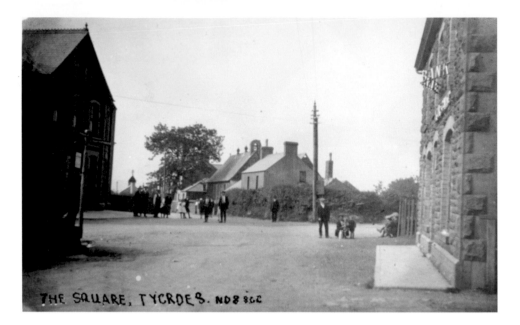

THE SQUARE, TYCROES. NO 8 &c

Tycroes, near Ammanford similarly was a quiet village where a photographer drew everyone's attention.

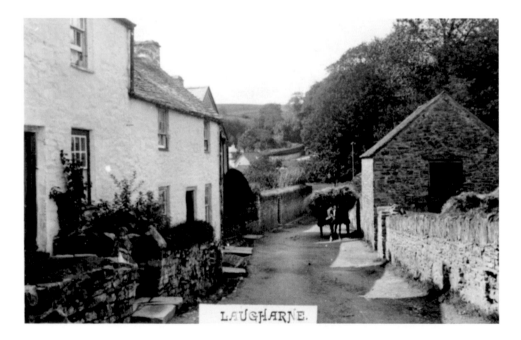

LAUGHARNE.

At Laugharne, however, only a hard-working horse bothered to pose for the camera, and he may have had no choice in the matter. Laugharne, of course, became famous in the 1950s as the home of celebrated Welsh poet and playwright Dylan Thomas.

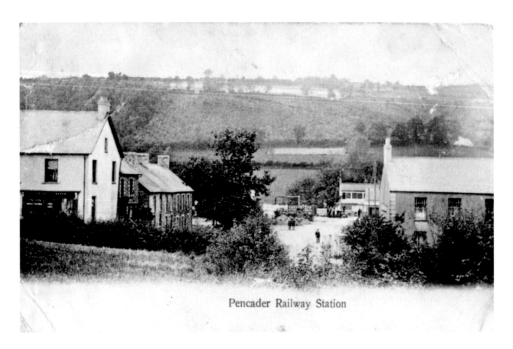

Pencader Railway Station

For many of the rural communities in Wales, the railway was an important link with the outside world. Postcards showing railway stations, such as this of Pencader are now very popular with collectors.

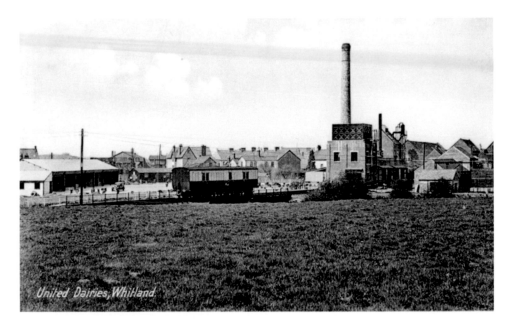

United Dairies, Whitland

West Wales did not have many large employers in Edwardian times. One was the United Dairies Creamery at Whitland, which closed in 1994.

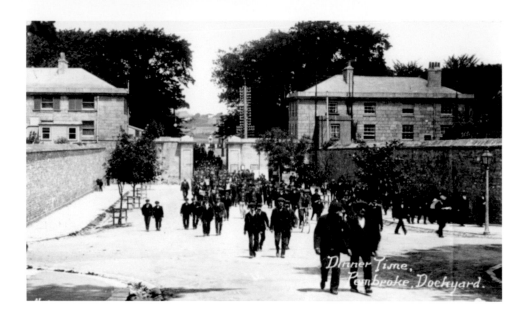

Another large employer was the Royal Naval Dockyard at Pembroke Dock. These dockyards were founded in 1814, before which time no community existed here. They closed in 1926, but had been considered one of the top dockyards, with a reputation for excellent workmanship.

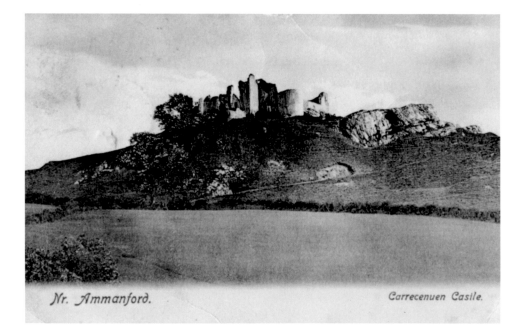

Nr. Ammanford. Carrecenuen Casile.

Carreg Cennen Castle near Ammanford is but one of many castles in West Wales to be represented on postcards.

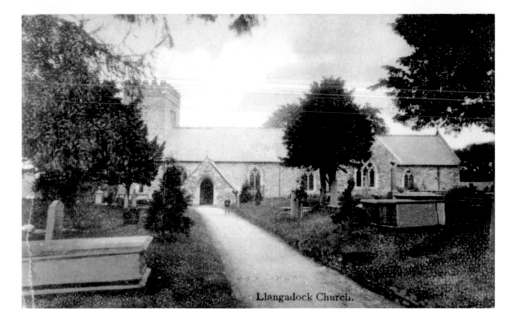

Llangadock Church.

Churches, too, are well represented, as in this attractive early card of Llangadog Church. The village name on the postcard is spelled 'Llangadock' which is the anglicised version.

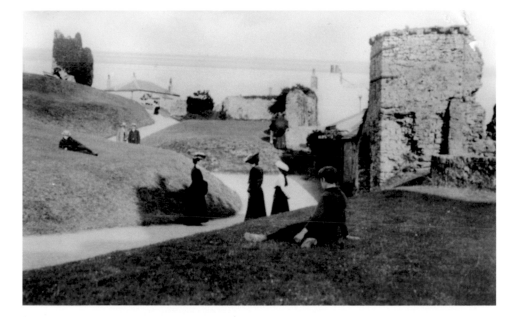

Tourism in West Wales was centred on the popular seaside resort of Tenby. Not much remained of the castle, but the grounds were a popular place to walk.

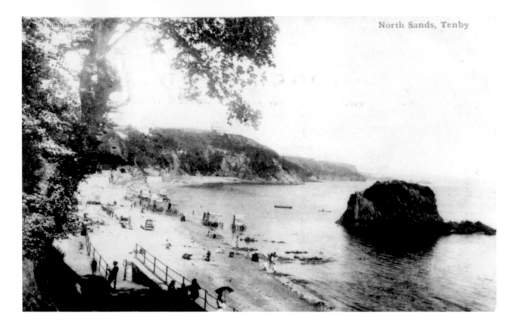

Tenby is blessed with two beaches – the North Sands, shown here, which were considered to be somewhat more secluded. Note the bathing machines, an important feature on Edwardian beaches, as the ladies' modesty had to be maintained.

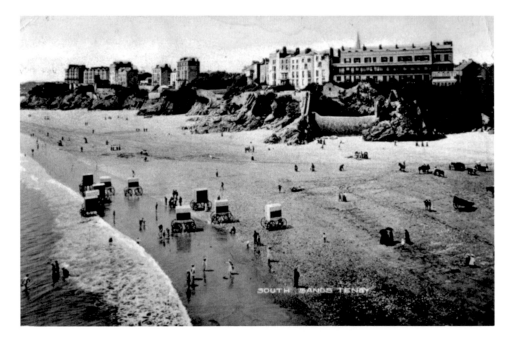

Tenby's other beach, the South Sands, were overlooked by some large hotels and boarding houses. Here, again, the bathing machines can be seen at the water's edge.

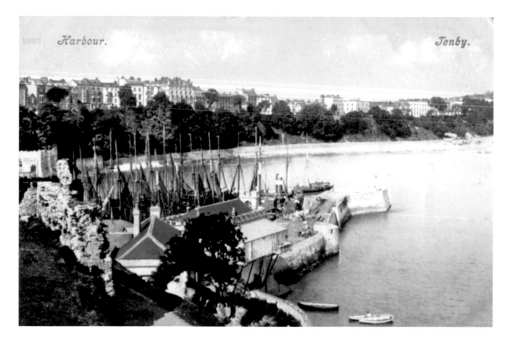

Tenby also boasted a small harbour, shown filled with sailing craft in this view.

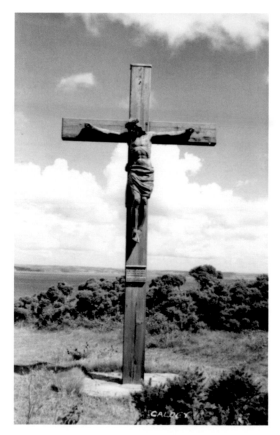

Just off Tenby lies Caldey Island, dominated by its monastery. The island's only connection with the mainland is by sea, and although tourists are welcome, the monks live a life of peaceful contemplation. This postcard from about 1910 shows a wayside cross on the island.

South Wales

South Wales encompasses the counties of Glamorganshire and Monmouthshire. It is in these two counties that the majority of the Welsh population live, and they are the industrial heartland of the country. The valleys of South Wales were dominated by coal mines, although the Swansea Valley was also the world centre for metallurgical industries such as copper. On the coast were the docks that fed the coal to the rest of the world – Swansea, Port Talbot, Barry, Cardiff and Newport. These were all served by an intricate network of railways. There were also seaside resorts, such as Mumbles, Porthcawl and Penarth.

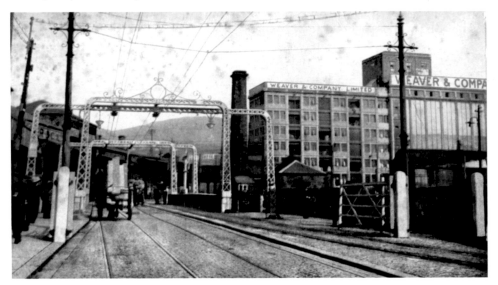

Swansea was a major port, shipping coal out, but also bringing in the ores that fed the furnaces of the copper industry, amongst others. The Lower Swansea Valley was filled with industry, the huge furnaces causing the night sky to glow. The town itself was huddled around the docks, and this card shows the new drawbridge that was built over the River Tawe. The Weaver & Company building was a flour mill, and was the first reinforced concrete building in the world.

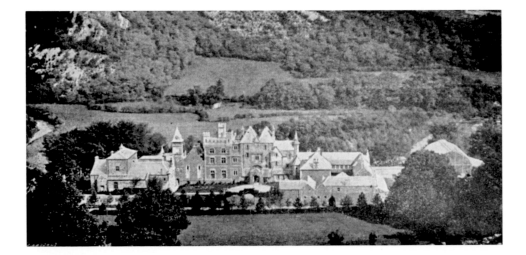

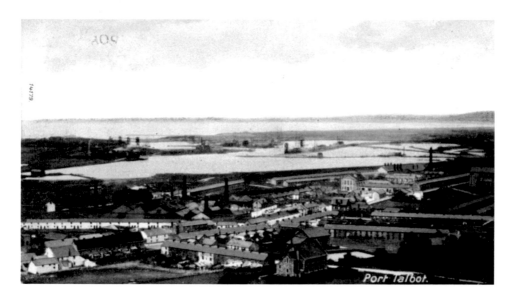

Port Talbot was developed by the Talbot family of Margam Abbey, and this view shows the town with the harbour beyond. The tall chimneys indicate the works that existed in the town at this time. The vast steelworks that today dominate the town were a later development.

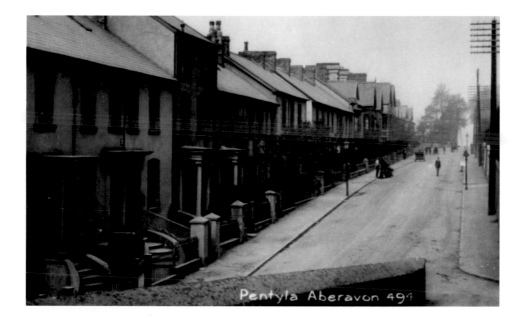

Port Talbot grew up around the older village of Aberavon, which continues to have a separate identity today as a residential area and seaside resort. This real photograph postcard shows Pentyla in Aberavon.

Opposite Below: High in the Swansea Valley, beyond the industrial area, stands Craig-y-Nos Castle, home of the opera diva Dame Adelina Patti. The large glass building seen on the right of this picture was later removed to Swansea and re-erected as the Patti Pavilion, and is used as a venue for concerts, shows etc.

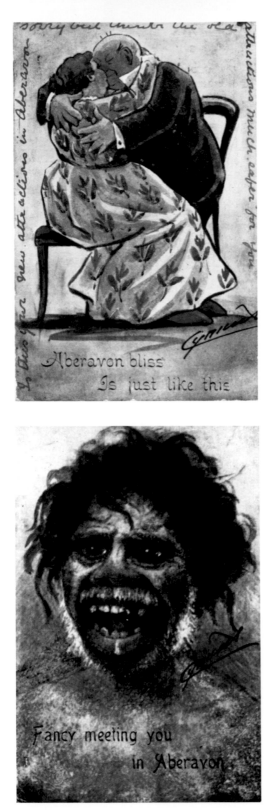

Comic postcards similar to these were produced in great numbers in Edwardian times. On to standard illustrations would be printed different captions with different town names, so making each card a 'local' card. Both of these were published by Cynicus, a major producer of these cards.

Visiting a photographer to have a posed photograph taken was popular in Edwardian times. The resulting photographs were often printed as postcards, with a divided back, enabling them to be sent to friends and relatives. This type of postcard is quite common, and often there is no indication as to who the person depicted was. Sometimes, however, a note on the back gives us some information. This card features Walter, who was a footman at Margam Abbey, and he sent it to his counterpart at the Talbot's other South Wales residence, Penrice Castle in Gower.

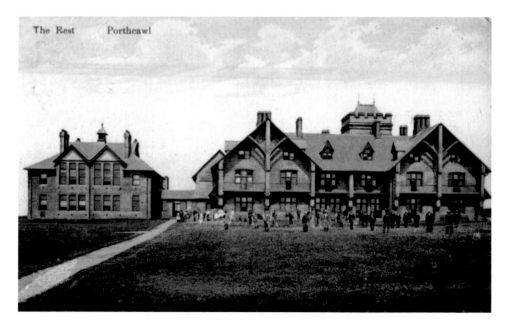

The seaside resort of Porthcawl was popular with day-trippers from the South Wales valleys, who could reach the town easily by railway. As with the North Wales resorts we have already seen, Porthcawl, too, had a convalescent holiday home at The Rest on Rest Bay.

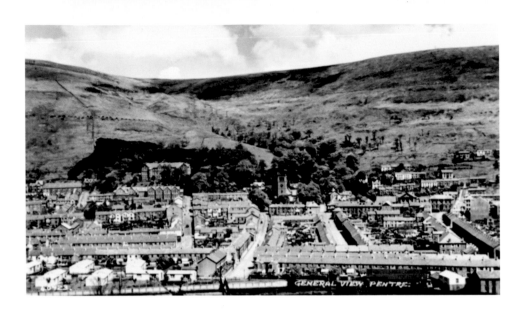

For many people, South Wales means coal mines and long rows of miner's cottages clinging to the side of a wet Welsh valley. Although a later card, this view gives a good impression of a typical town in the Rhondda Valleys. This is Pentre, and as can be seen, the town stuck pretty much to the valley floor, with the open, undeveloped hillside just beyond.

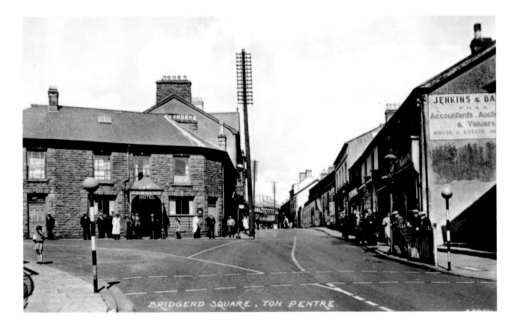

This card, showing Bridgend Square, Ton Pentre, with the Bridgend Hotel on the corner, is also a later card, but it does show what a town in the Rhondda was like for much of the first half of the twentieth century.

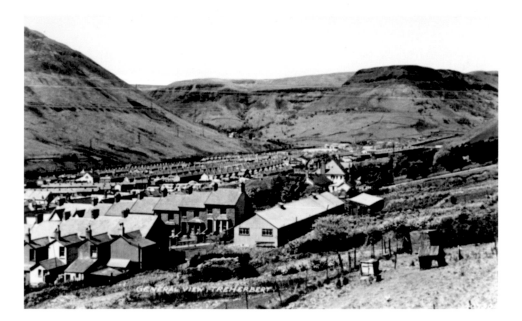

At the top of the Rhondda Valley, Treherbert seems enclosed by the stark hills around it, and here the railway lines came to an end.

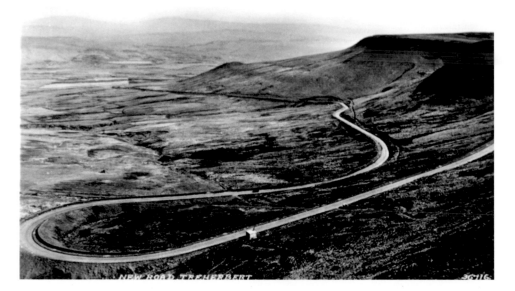

However, road users can go on the perilous journey over the Rhigos Mountain to Hirwaun at the top of the Cynon Valley.

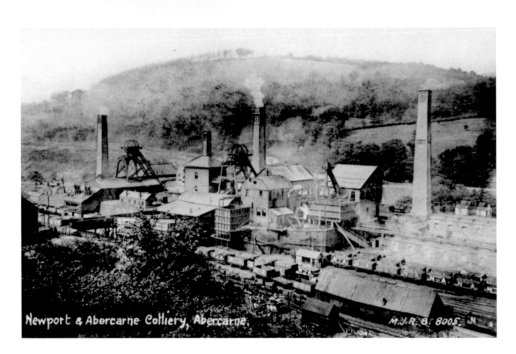

Newport & Abercarne Colliery, Abercarne. M.J.R.B. 8005. N A

The valleys of South Wales, were, of course, dominated by collieries. This postcard shows a typical colliery, the Newport and Abercarne Colliery at Abercarne in Monmouthshire. Note the large number of coal trucks, each marked N & A to indicate to which colliery they had to be returned.

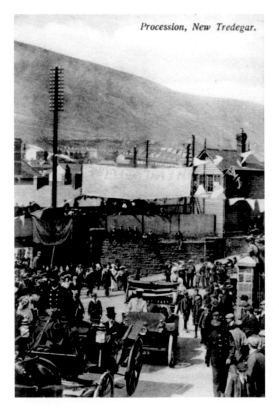

Procession, New Tredegar.

Also on the industrialised western edge of Monmouthshire, New Tredegar was a typical valleys town. This card is only captioned 'Procession, New Tredegar', but seems to show a Royal Visit – probably not the King though – to the town. Unfortunately the card is not dated.

Working underground in a coal mine was hard, dangerous work. In the early years of the twentieth century most of this work was done by hand, as it had been for generations. Mechanisation was for the future. This *Western Mail* postcard shows miners working in a stall underground.

This card, from the same series, depicts a miner 'ripping top'.

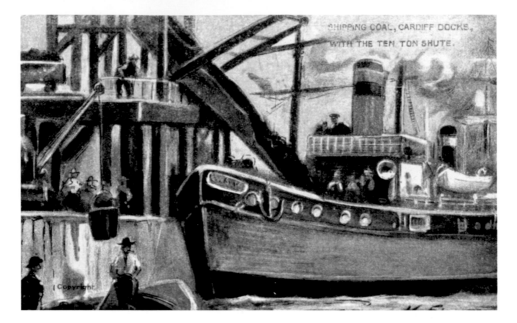

Most of the hard-won coal was taken by rail to the docks for export. This postcard, reproducing a painting by the artists H. Fleury, shows coal being loaded onto a ship with the Ten Ton Shute at Cardiff Docks.

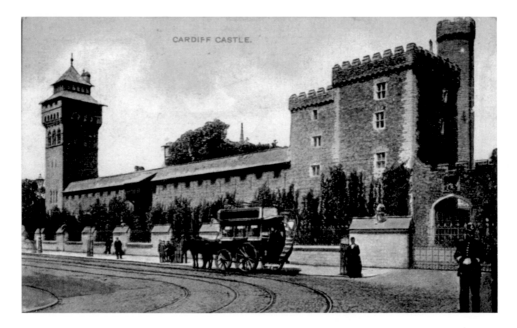

At the beginning of the twentieth century Cardiff was – and indeed still is – the largest city in Wales. In 1922 it became the capital, but had been pre-eminent throughout the latter half of the nineteenth century. Its development had in no small part been due to the vision of the Marquess of Bute. It was he, together with William Burges who rebuilt and refurbished Cardiff Castle from 1866 onwards.

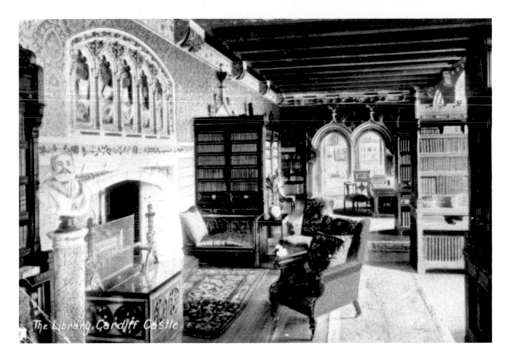

The style was in line with the tenets of the Gothic Revival, which mean that both the interior and exterior of the castle was recreated in as close a style to the medieval as possible.

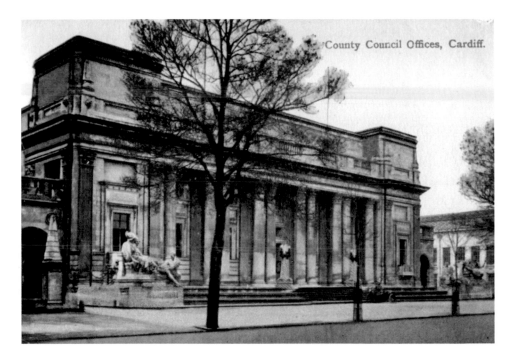

County Council Offices, Cardiff.

The public buildings in Cardiff were also built on a grand scale. Postcards reflected this civic pride, as with this view of the Glamorgan County Council Offices.

The new University buildings in Cathays Park were also the source of much civic pride.

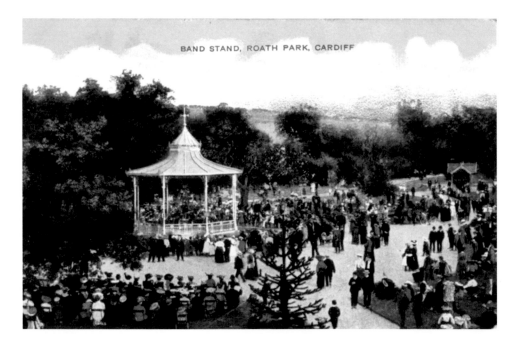

This pride in the city meant that there were parks and gardens laid out, where the citizens could walk and be entertained. Bandstands such as the one here at Roath Park provided outdoor concerts.

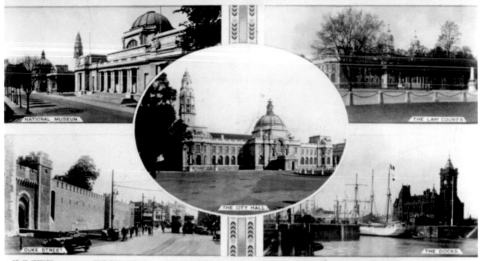

CARDIFF HAS THE BEST COAL, ELECTRICITY, WATER, TRANSPORT, AND A SITE FOR YOUR FACTORY

NATIONAL MUSEUM

THE LAW COURTS

DUKE STREET

THE CITY HALL

THE DOCKS

INVITE YOUR FRIENDS TO CARDIFF : THE MOST BEAUTIFUL CITY IN WALES

Postcards were used as a means of promoting Cardiff, and this one pulls no punches in its praise for the city.

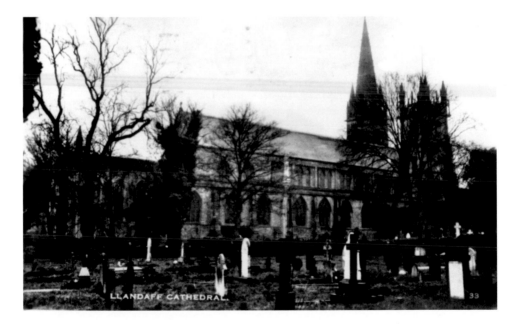

LLANDAFF CATHEDRAL

33

The Cathedral at Llandaff drew many visitors to Cardiff. The cathedral church of Saints Peter & Paul, Dyfrig, Teilo and Euddogwy was begun in 1107, but in 1941 was badly damaged by a German landmine. It was largely rebuilt and restored to its former glory by the architect George Pace between 1949 and 1957.

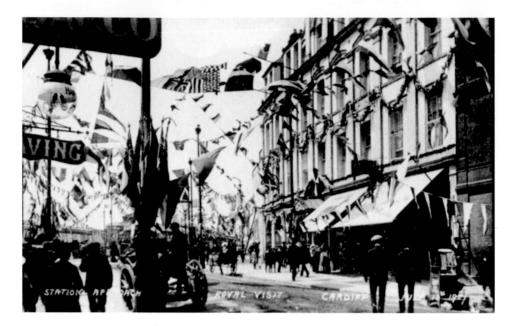

Perhaps the greatest show of civic pride came in 1907, when the King and Queen made a Royal Visit to the city. The streets were festooned in decorations, as was the Station Approach, shown here.

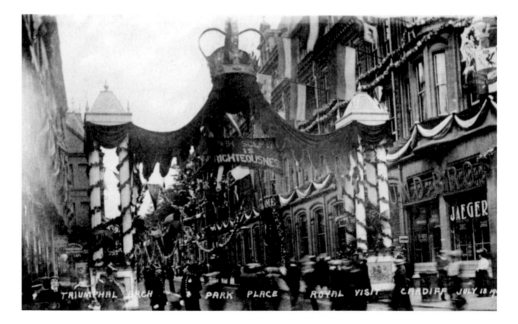

A triumphal arch was erected in Park Place. Other postcards in the same series show the decorated streets, the crowds in Cathays Park, and the children seated in special areas where they would get a good view of the Royal couple.

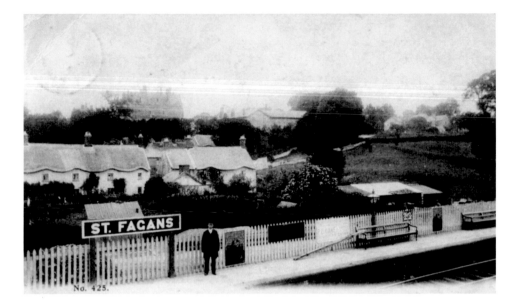

No. 425.

Just outside Cardiff, the charming village of St Fagans was rural backwater in the early years of the twentieth century. Here, the spick and span railway station is shown, with a proud stationmaster posing for the camera.

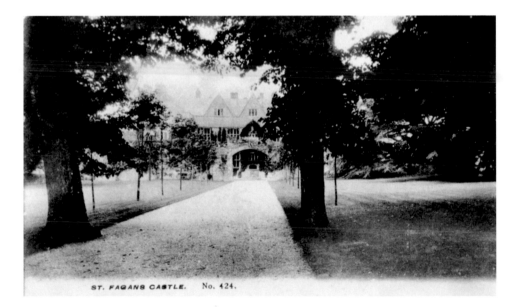

ST. FAGANS CASTLE. No. 424.

St Fagans Castle was the seat of the Earl of Plymouth, and later was given to the people of Wales as the home of the National Folk Museum.

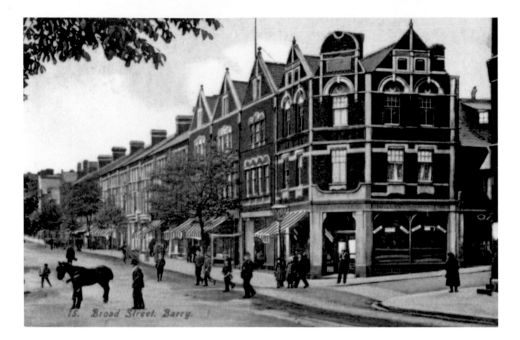

The clean streets of Barry, shown on this postcard of Broad Street, belie the closeness of Barry Docks, a major port for the export of coal.

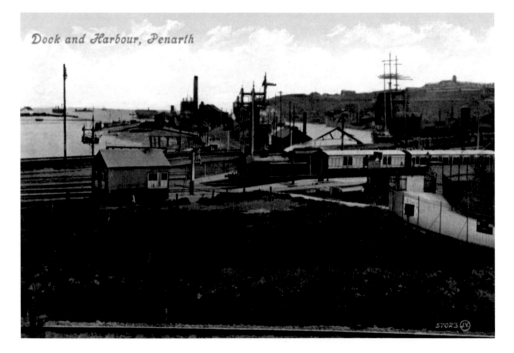

Penarth, across the bay from Cardiff, also had a harbour and dock, that are featured on this card, which also shows a Taff Vale Railway train at the station.

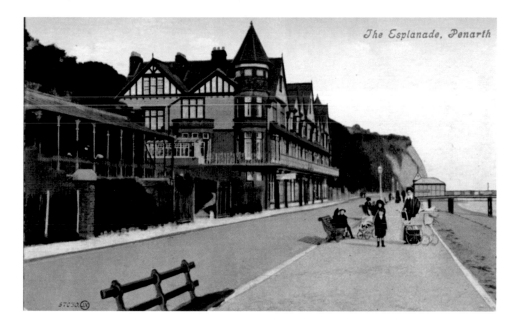

The Esplanade, Penarth

Penarth's sandy beach attracted holidaymakers, although there were few visitors on the day this photograph was taken.

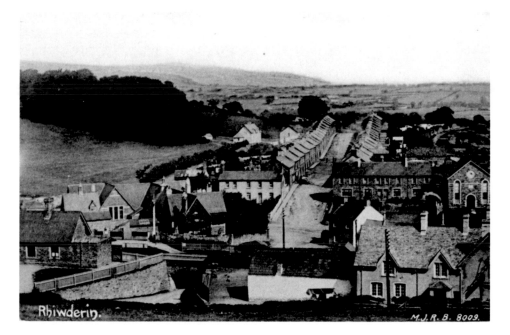

Rhiwderin.

M.J.R.B. 8009.

This journey has already touched the industrialised western valleys of Monmouthshire, and close to Newport, the largest town in the county, Rhiwderin also is typical of many villages with its long terraces, chapel and railway station.

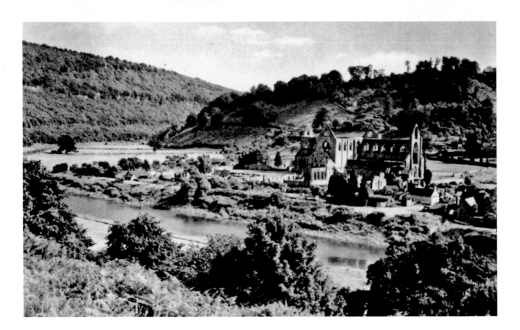

By contrast, at the eastern edge of the county, the River Wye forms the boundary between Wales and England. The gentle countryside is in complete contrast to the industrialised area. Here, alongside the river stand the ruins of Tintern Abbey, a major tourist attraction which, together with Chepstow Castle, brought thousands of visitors a year to this border country.

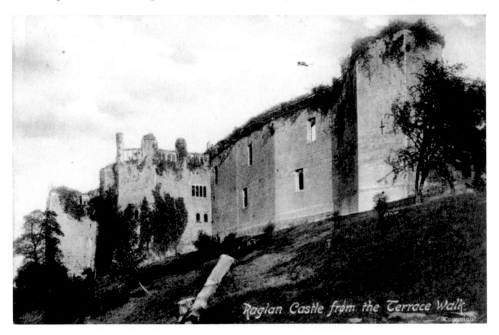

Raglan Castle from the Terrace Walk.

Finally, our tour ends at Raglan, in central Monmouthshire. The present castle at Raglan dates from 1435 and is considered by many to be the last true castle built in England or Wales. The magnificent ruin was also a draw for tourists and day trippers. This is just one of the many cards that a visitor could send home.